IMAGES
of America

McDougall's Great
Lakes Whalebacks

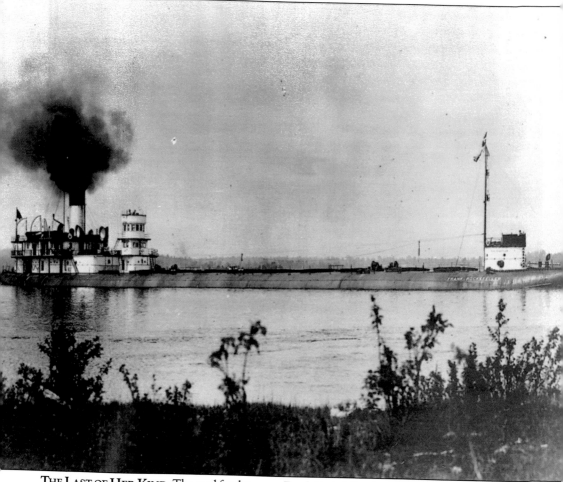

THE LAST OF HER KIND. The coal fired steamer *Frank Rockefeller*, launched on Saturday, April 25, 1896, at West Superior, Wisconsin, is 366.5 feet long with a beam of 45 feet and a draft of 26 feet. She began her career with a 1,195 horsepower triple expansion engine and three Scotch boilers, all built by the Cleveland Shipbuilding Company. As the *Frank Rockefeller*, she had 10 hatches on 24-foot centers leading to three compartments that could hold 5,200 tons of bulk cargo. In 1928, the steamer was renamed the *South Park* and continued her Great Lakes sailing career as an automobile carrier and then as a sand sucker. In 1943, the *South Park* was reconfigured to a bulk liquid tanker and renamed the *Meteor*. The *Meteor* carried petroleum products over the Great Lakes for many years until she was retired in 1969. In 1972, the *Meteor*, the last whaleback still afloat, was brought back to life as a remarkable marine museum on Barker's Island in Superior. (Author's collection.)

On the cover: **THE STEAMER PROGRESS.** The whaleback steamer *Progress* is tied up at the Soo Locks in the early 1920s. (Courtesy of the Historic Photo Collection/Milwaukee Public Library.)

IMAGES
of America

McDougall's Great Lakes Whalebacks

Neel R. Zoss

ARCADIA
PUBLISHING

Copyright © 2007 by Neel R. Zoss
ISBN 978-0-7385-5143-2

Published by Arcadia Publishing
Charleston, South Carolina

Printed in the United States of America

Library of Congress Catalog Card Number: 2007926219

For all general information contact Arcadia Publishing at:
Telephone 843-853-2070
Fax 843-853-0044
E-mail sales@arcadiapublishing.com
For customer service and orders:
Toll-Free 1-888-313-2665

Visit us on the Internet at www.arcadiapublishing.com

*With much love to my wonderful wife, Judy,
who makes all things possible.*

CONTENTS

Acknowledgments 6

Introduction 7

1. Alexander McDougall and the American Steel
 Barge Company 11

2. The Whaleback Barges 19

3. The Whaleback Steamers 59

4. The S.S. *Meteor*, the Last Whaleback 111

ACKNOWLEDGMENTS

Few works such as this are completed in a vacuum and this volume is certainly no exception. Many wonderful people assisted me in gathering and presenting the material contained herein. A humble, profound, and warm thank-you to the following folks for much assistance, guidance, and support: Laura Jacobs, assistant professor at the University of Wisconsin–Superior and archivist of the Maritime Collection of the Jim Dan Hill Library; Stan Radosevich of Coon Rapids, Minnesota; the staff of the National Archives and Records Administration center in Chicago; Kenneth B. Miller Jr., director of the Bayliss Public Library at Sault Ste. Marie, Michigan; Sara Jackson, administrative coordinator of the Superior (Wisconsin) Public Museums; Suzette Lopez, clerk of the Milwaukee Public Library's Great Lakes Marine Collection; Marilyn Gannon of Muskegon, Michigan's Hackley Public Library; Judy Schlaack, registrar, and Kristen Edson, archivist, of the Marialyce Canonie Great Lakes Research Library of the Michigan Maritime Museum; Christopher Gillcrist, executive director, and Carrie Sowden, archaeological director, of the Great Lakes Historical Society; Marci Andrews of Cornell Maritime Press; Theresa Lieb and her colleagues at the New Jersey Historical Divers Association; Samantha Mirabella and Francis Donovan of the United States Corps of Engineers Cape Cod Canal Field Office; Michael See, my very good friend of Hudsonville, Michigan, for the incredible amount of technical support and computer assistance he provided; Matthew L. Daley, Ph.D., archivist of the University of Detroit Mercy and curator of the University of Detroit Mercy; Rev. Edward J. Dowling, S. J. Marine Historical Collection for his extraordinary generosity, significant insight, and deep knowledge regarding the whalebacks; and, of course, my wife Judy, for wholeheartedly supporting this project and allowing me free reign to roam about the Great Lakes to complete the work.

INTRODUCTION

Between the years 1888 and 1898 Capt. Alexander McDougall manufactured 43 whaleback vessels—unique, strange, and curious looking boats—that garnered fame, awe, and a bit of fortune as they sailed across the Great Lakes and along America's near shore coasts. The vessels, a radical departure from the standard Great Lakes ship designs of the day, also garnered stinging criticism, derisive comments, and outright skepticism from many of the dyed-in-the-wool Great Lakes sailors who viewed McDougall's ideas as simply too much too soon.

Unable to find financial support to build his radical new vessel, McDougall spent a large share of his own money to build his first whaleback, *Barge 101*, in 1888. There is a story that as *Barge 101* slid down the ways into Duluth Harbor, McDougall's wife, Emmeline, turned to her sister-in-law and stated, "There goes our last dollar." Fairly much the prototype of the subsequent whaleback barges, *Barge 101* had a turret at her bow and her stern and both were eight feet in diameter and seven feet tall. The aft turret was topped with a 10-foot-by-12-foot open-air wooden pilothouse. Interest increased after *Barge 101* proved herself on the lakes and, in 1889, McDougall formed the American Steel Barge Company in Duluth, Minnesota, with the backing of John D. Rockefeller to build the strong, sturdy, efficient whalebacks. McDougall built 42 more whaleback barges and steamers over the next 10 years before circumstances converged to end their viability and production ceased.

To say the least, McDougall's ideas, regarding both the design and the construction of his boats, were certainly new and different. From the keel up, McDougall gave his steamers and barges a flat bottom for increased stability and curved sides to help his boats cut more efficiently through the water and to aid the self-trimming feature that allowed the whalebacks to load fairly quickly. McDougall developed a curved spar deck for his boats for additional strength (employing the engineering principle of the arch) and to provide a surface that would not retain water. To further streamline his boats, McDougall built them with an upturned, snout-like bow (a design so foreign that they actually formed the basis of the less-than-desirable nickname given to the whalebacks: pig boat) and tapered the aft so that the boats could slip through the water with less effort than conventional boats. The upturned bow also had the additional benefit of being very useful in ice breaking. On the curved spar deck McDougall designed round turrets so that fewer flat surfaces resisted the wind and water. The turrets housed and supported crew quarters, the pilothouse, and access hatches to the interior of the boat. In addition to the other innovations McDougall presented, he placed his pilothouse at the stern of his boats (with the exception of the steamers *Christopher Columbus*, *John Ericsson*, and *Alexander McDougall*) in complete opposition to the standard design of the Great Lakes freighters of the day. Even the

material used to manufacture the whalebacks was unusual considering that the first all-steel bulk carrier on the Great Lakes was built just a few short years before McDougall's steel boats began plying the lakes.

McDougall, a Great Lakes sailor and captain for many years, used his experience, expertise, and innate business ability to incorporate a number of new and innovative ideas to design and manufacture what he believed was a stronger, more stable boat for carrying bulk cargo. McDougall envisioned that by presenting a lower profile to the wind and wave, especially when loaded, and by allowing water to wash over the decks of the whalebacks he could improve the effectiveness and efficiency of the boats by reducing the resistance between his boats and the sea. It is storied that McDougall found his low profile, waves-awash inspiration by watching a log floating on the water during a storm. As the story goes, the captain observed that the log, sitting low in the waves with just its very top above water, was rolling and pitching far less than the other flotsam that was resting on top of the water. For a number of years after the introduction of the whalebacks a comparison of the operational costs of the whaleback versus the conventional lakers of the day proved McDougall correct. McDougall's designs altered, at least for a time, some of the long-held ideas that had permeated the Great Lakes boat-building business for decades. Indeed, even though the whalebacks were built for less than 10 years, a number of McDougall's boat-building visions long outlived McDougall and his boats, not the least of which was the concept of streamlining. In time however, the economy of larger boats carrying larger cargos combined with the inherent structural problems of the whalebacks to bring an end to the era of the pig boats.

For all the advantages possessed by the whalebacks there were problems—some small, some not so small. The minor problems, the problems that would have been designed away over time, consisted mainly of inconveniences related to the basic design of the boats. Many of the work compartments and the engine rooms were cramped and dark and damp due to the fact that they were deep in the boat's hulls and almost always below the water line. There were no interior tunnels or walkways to connect the fore and aft sections of the boats so that during heavy weather (and even during normal operations), with waves running over the deck, the crewmen in the forward compartments and work areas were completely cut off from the aft section. Because of the unique bow of the whalebacks and because the ballast tanks inside the double hulls could not hold enough water to keep them low in the seas, it was sometime difficult to handle an empty whaleback against the wind. There was also a minor problem created by the arched spar deck: any cargo spilled during the loading/unloading processes was lost overboard. Had these small problems been the only difficulties with the whalebacks they would still be manufactured today. Had it not been for the more serious structural problems that limited the size of the whalebacks, they may well have revolutionized Great Lakes ships and shipping forever.

The problems that were directly related to the demise of the whalebacks were, ironically, directly related to the advantages that made the whaleback design successful at the outset of their sailing days. Because of the curved decks and curved hulls of the whalebacks—one of the major design features that was responsible for making them more efficient than conventional lakers of the late 19th and early 20th centuries—the beam of the whalebacks was limited to approximately 45 feet due to the loss of right angle supports above and below the hold. The curved decks also confined the size of the cargo hatches. Because of the limited beams, the load a whaleback could carry, in an era of ever larger boats carrying ever larger cargos being regularly built, was comparatively ever smaller and more expensive. The size of the hatches on the whalebacks continued to reduce the number of ports open to the boats as more and more ports were equipped with loading/unloading equipment that was simply too large to deal with the small hatches on the boats. Time being one of the enemies of efficiency, the whalebacks were required to spend more time in port loading and unloading thereby decreasing their cost effectiveness.

There were attempts to correct the internal structural problems of the whalebacks by McDougall and the engineers of the American Steel Barge Company. The steamer *John Ericsson*

and the barge *Alexander Holley* (both launched in 1896) were fitted with internal supports to allow their beams to reach in excess of 45 feet but, unfortunately, the supports interfered with the loading/unloading process and actually reduced the size of the holds relative to the size of the boat. The last whaleback built, the *Alexander McDougall* launched in 1897, had a beam of 50 feet but she was constructed with a conventional bow structure and a pilothouse forward in order to increase the strength of her hull. Because of her mostly conventional construction, the *Alexander McDougall* is very close to not actually being a whaleback at all.

The attempts by McDougall to improve his whalebacks ultimately failed and the whaleback design fell out of favor. The boats simply could not be built large enough to meet the demands of the Great Lakes cargo trade and still maintain their cost effectiveness.

The whalebacks were built for less than 10 years, mostly in Duluth, Minnesota, and West Superior, Wisconsin. Their deficits not withstanding, the whaleback barges and steamers were solid and hardy and came to fill certain niches in the Great Lakes shipping world. After the American Steel Barge Company ceased production of the whalebacks, the boats continued sailing the Great Lakes, the coastal seaboards of America, and many of the world's seven seas. Many of McDougall's odd boats remained in service for 30, 40, 50, and more years—two of the whalebacks, the barge *Alexander Holley* and *Barge 137*, sailed for 69 years before being scrapped. The steamer *John Ericsson* sailed for more than 70 years before being cut up, and the *Meteor* (launched as the *Frank Rockefeller* and later sailing under the name *South Park*) worked on the Great Lakes for an astounding 73 years before she began her second career as a remarkable maritime museum in Superior, Wisconsin.

During their sailing years on the Great Lakes any number of McDougall's boats found themselves involved in activities not considered exactly shipshape. In August 1913, the steamer *Atikokan* ran aground at Marine City, Michigan, on the St. Clair River. Although running aground was not terribly unusual for vessels in that era, running aground and knocking over several buildings ashore was. The *Atikokan* needed a number of tugs to pull her off the shore and back into the river. The steamship *Henry Cort* was the whaleback that sailed, almost constantly, under a very large and very black cloud. During her 42 years of sailing on the Great Lakes the *Henry Cort* sank no less than three times, was involved in no less than three collisions with other boats, ran aground several times, and was involved in the deaths of at least four people. In October 1902, during a Lake Superior storm, *Barge 129* was ignominiously rammed and sunk by her own towing steamer, the *Maunaloa*, off Vermilion Point, Michigan.

After their Great Lakes days, a fair number of the whaleback steamships and barges found themselves working in the coal trade along the Atlantic seaboard and in the Gulf of Mexico running in the bulk petroleum business during the early and middle 20th century. Several of the whalebacks roamed the world's oceans hauling their cargos to and from faraway ports. The steamer *City of Everett* was the first American ship to transit the Suez Canal and was also the first American steamer to circumnavigate the earth. The *City of Everett* also had the distinction of actually capturing the town of Malaga, Spain, at the outset of the Spanish-American War when the unarmed steamer entered the Malaga harbor in search of fresh water, not knowing that the troubles brewing between Spain and the United States had reached a war fever. After the steamer had anchored in the harbor, officials of the town sailed out to the *City of Everett*, greeted the captain and crew and promptly surrendered their town.

The whaleback steamer *Charles W. Wetmore* sailed from Duluth, Minnesota, with a load of wheat in June 1891 for Liverpool, England. The problem with the planned trip was that the steamer was too large to fit through the locks and canals on the St. Lawrence River. The *Charles W. Wetmore* became the first steamship to shoot the Lechine Rapids with none other than Capt. Alexander McDougall piloting the boat through the hazardous waters. After the boat successfully ran the rapids she continued her sail to England, arriving in 11 days. The *Charles W. Wetmore* created such excitement upon her arrival at Liverpool that she was opened for public tours. Charging a one shilling admission, the boat was able to raise more than 100£ that was subsequently donated to the Liverpool Sailor's Orphanage.

Beginning on June 23, 1888, when the steel hull of the first whaleback every built, *Barge 101*, touched the eternally frigid waters of Lake Superior to this very day when only one example of McDougall's innovative dream, the steamer *Meteor*, still exists, the whalebacks captured the attention and imagination of all who saw them. Through many years and many adventures, McDougall's whalebacks earned an honored place in the lore of Great Lakes sailors and their boats.

One

ALEXANDER MCDOUGALL AND THE AMERICAN STEEL BARGE COMPANY

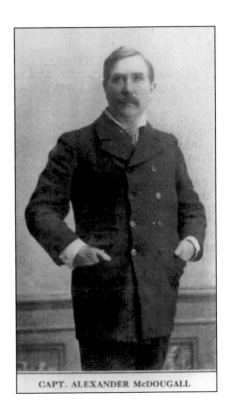

CAPT. ALEXANDER McDOUGALL. The father of the whalebacks, Capt. Alexander McDougall (1832–1924) withstood storms of criticism and ridicule to follow his dream of building his innovative barges and steamships. McDougall, successful Duluth businessman, ship captain, entrepreneur, speculator, and visionary, was very much a 19th century renaissance man. (Courtesy of the University of Detroit Mercy Special Collections, Fr. Edward J. Dowling, S. J. Marine Historical Collection.)

CAPT. ALEXANDER McDOUGALL

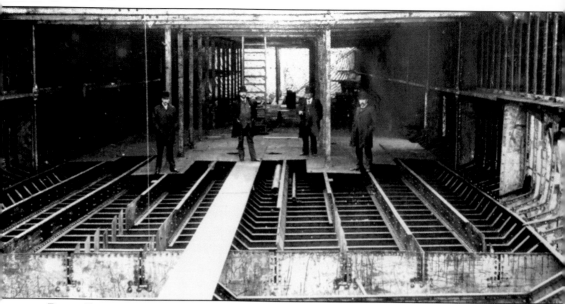

RARE PHOTOGRAPH—TWICE. In this early-1890s photograph two rare events are captured in a single image. The first, Capt. Alexander McDougall (the man in the long coat on the extreme right) is shown in one of the very few photographs of him that have survived. For all his business enterprises, all his significant achievements, all his travels, and all his community activities, there are remarkably few pictures known to exist of McDougall. The second, the interior construction of one of McDougall's boats is shown in detail. McDougall and the other men are shown standing on the steel plates that will be riveted to the steel I beams below them to form the deck of the boat's cargo hold. The steel skeleton of the boat's hull is clearly visible and provides an excellent view of the internal structure of the early whalebacks. (Courtesy of the University of Detroit Mercy Special Collections, Fr. Edward J. Dowling, S. J. Marine Historical Collection.)

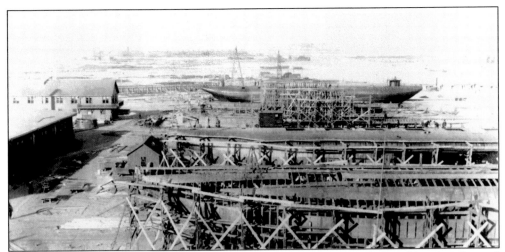

AMERICAN STEEL BARGE COMPANY SHIPYARD. In 1888, McDougall placed his first shipyard at Rice's Point in Duluth. The first seven whalebacks were launched from there. In 1890, McDougall moved his entire shipbuilding operation from Duluth to Howard's Pocket at West Superior, Wisconsin. Almost all the remaining whalebacks would be launched from the West Superior shipyard. (Courtesy of the University of Detroit Mercy Special Collections, Fr. Edward J. Dowling, S. J. Marine Historical Collection.)

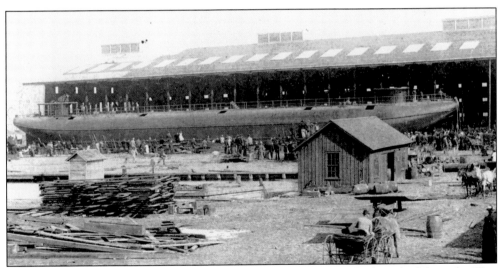

WHALEBACK BARGE READY FOR LAUNCH. This barge is about to be launched from the West Superior yard of the American Steel Barge Company. The barge will need additional work after she is in the water—the pilothouse has not been placed atop the aft turret—but she is, for all practical purposes, ready for service. (Courtesy of the University of Detroit Mercy Special Collections, Fr. Edward J. Dowling, S. J. Marine Historical Collection.)

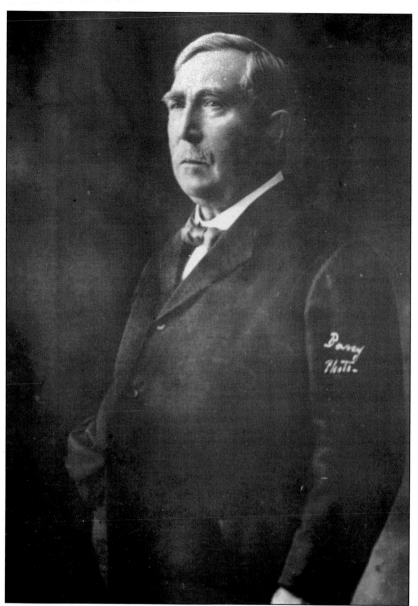

AN OLDER ALEXANDER MCDOUGALL. Alexander McDougall was born on the Island of Islay, Scotland, on March 16, 1845, and, with his family, emigrated to Nottawa, Ontario, at age nine. McDougall's father was killed in 1855 leaving the 10 year old as the man of his family. Over the next several years McDougall worked many jobs to support his mother and four younger siblings. At age 16 McDougall began his sailing career as a deckhand on the steamer *Edith*, sending almost all his pay home to his family. McDougall very quickly rose through the ranks and, at the young age of 25, was named captain of the steamer *Thomas A. Scott*. McDougall's talents were recognized by many on the Great Lakes and he was asked to oversee the building of several Anchor Line steamers and even traveled to Russia for the Anchor Line to review the shipping business there. In 1888, McDougall began building his whalebacks at Duluth and made his name in Great Lakes history. McDougall died on May 23, 1923. (Courtesy of the Lake Superior Marine Collection, University of Wisconsin–Superior.)

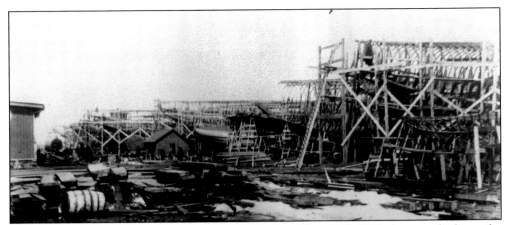

AMERICAN STEEL BARGE COMPANY IN ITS HEYDAY. This 1892–1893 photograph shows the amount of work that was undertaken by the American Steel Barge Company (ASBC) in its heyday. There were 8 whalebacks built in 1890, 9 were built in 1891, 10 in 1892, and 6 in 1893. At its busiest, ASBC employed several hundred workers. (Courtesy of the University of Detroit Mercy Special Collections, Fr. Edward J. Dowling, S. J. Marine Historical Collection.)

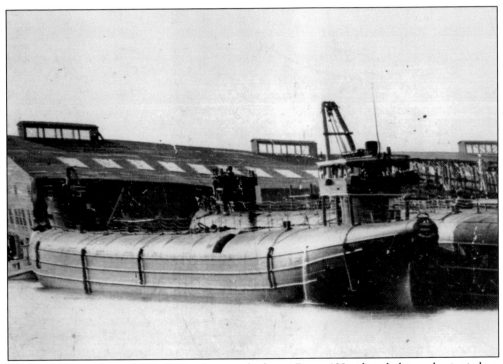

BARGE 129 AT HOME. This 1890s photograph shows *Barge 129* riding light as she is tied up alongside a whaleback steamer at the ASBC shipyard in West Superior, Wisconsin. (Courtesy of the University of Detroit Mercy Special Collections, Fr. Edward J. Dowling, S. J. Marine Historical Collection.)

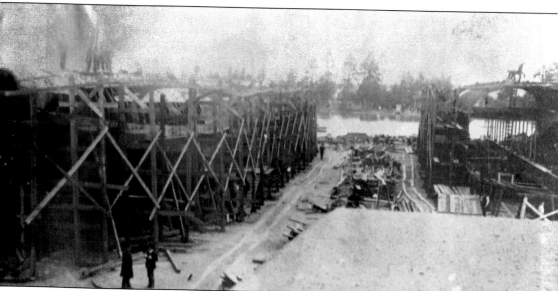

WHALEBACK BARGES UNDER CONSTRUCTION. Several of the earlier whaleback barges are shown under construction at the ASBC shipyard in West Superior, Wisconsin. The barge on the left is well on her way to completion while the barge on the right has recently begun her manufacture. The bending of the steel plates and ribs for the vessels was completed with the help of large presses in the ASBC shipyard but, overall, the construction of the whalebacks was completed with precious little assistance from power tools or machinery. Although horses and wagons lent assistance and steam-powered hammers were used to rivet the hull plates on the ribs, the moving and manhandling of parts and pieces of the boats was done mainly by the many men employed in the shipyard. (Courtesy of the University of Detroit Mercy Special Collections, Fr. Edward J. Dowling, S. J. Marine Historical Collection.)

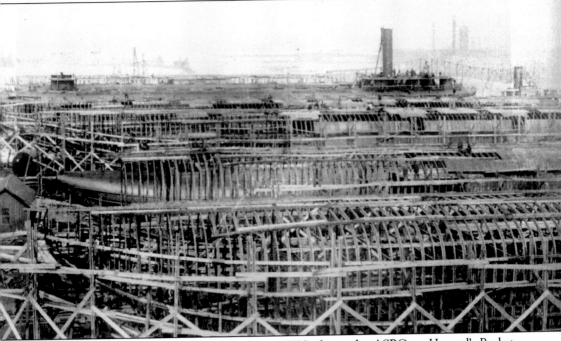

THE ASBC. This photograph, taken in 1892 or 1893, shows the ASBC on Howard's Pocket at West Superior in full swing with at least five whalebacks under construction. One of the hallmarks of Capt. Alexander McDougall's whalebacks was the relative ease of their construction as all the ribs that supported the middle section of the boat under construction were exactly the same. The uniformity of the ribs made building the vessel fairly simple with only the bow and aft sections requiring any complex bending of the steel plates that were then riveted to the ribs. The ribs of the whaleback in the foreground can clearly be seen as the boats sit in the wooden frames that surround them. (Courtesy of the University of Detroit Mercy Special Collections, Fr. Edward J. Dowling, S. J. Marine Historical Collection.)

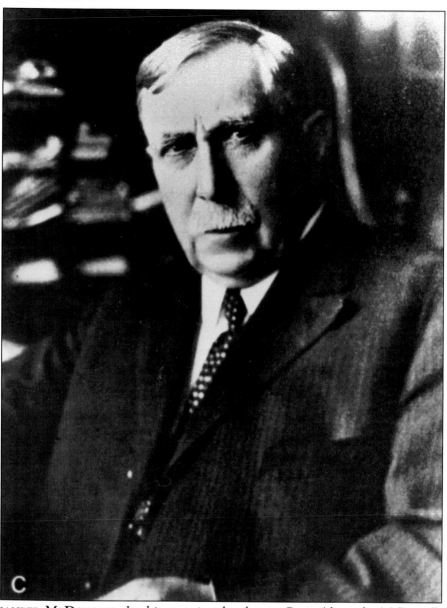

ALEXANDER MCDOUGALL. In this portrait, taken late in Capt. Alexander McDougall's life, the image of a prosperous and well respected community leader is clearly reflected. McDougall, ever the businessman looking for opportunities, had a number of shore side enterprises over and above his participation in the ASBC. He owned a company that insured Great Lakes hulls and cargos, one of his companies directed most of the stevedore activities in Duluth in the late 1880s, he was the president of the Northern Power Company of Wisconsin and was seated on the board of directors of the Great Northern Power Company, the City National Bank in Duluth, and the Northeastern Power Company. Over his lifetime, McDougall applied for and was granted close to 40 United States patents and numerous foreign patents, almost all of them related to the shipping industry in one way or another. He testified on maritime matters in front of numerous state and federal government boards and committees and he wrote many articles about the shipping industry. (Courtesy of the Great Lakes Historical Society.)

Two

THE WHALEBACK BARGES

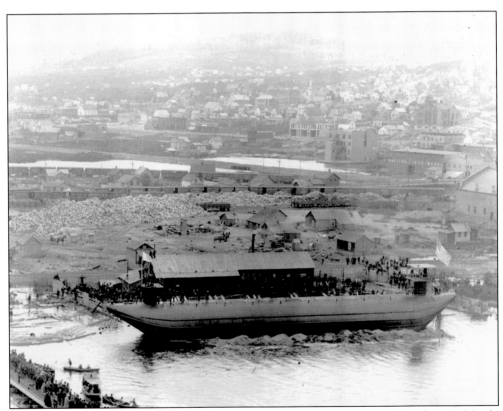

THE FIRST WHALEBACK. This historic photograph shows the launching of the first whaleback. *Barge 101*, the first whaleback constructed and the first all-steel boat built on Lake Superior, was launched at 3:04 p.m. on Saturday, June 23, 1888, in front of 3,000 people at Rice's Point in Duluth, Minnesota. Costing $40,000, *Barge 101* was 178 feet long, 25.1 feet wide and had a draft of 12.7 feet. (Courtesy of the Historic Photo Collection/Milwaukee Public Library.)

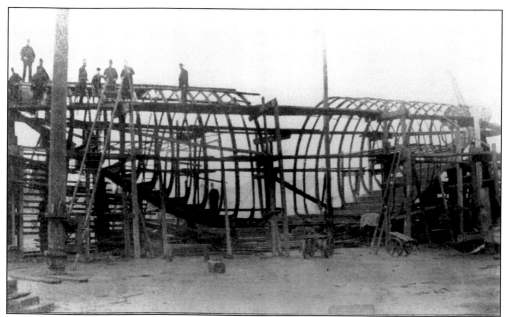

END FRAMES OF BARGE 101. The frames of the bow and stern sections of *Barge 101* were manufactured by the Pusey and Jones Company of Wilmington, Delaware, dismantled, crated and shipped to Capt. Alexander McDougall in Duluth for attachment to the center portion of the barge that was built at Rice's Point on the Duluth Harbor. (Courtesy of the University of Detroit Mercy Special Collections, Fr. Edward J. Dowling, S. J. Marine Historical Collection.)

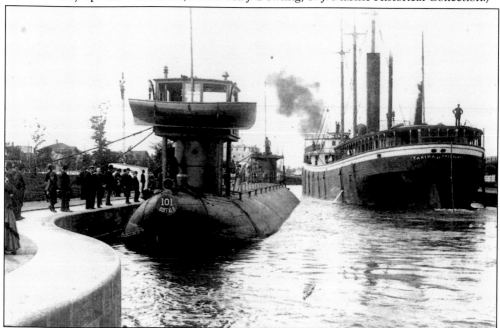

BARGE 101 IN SOO LOCKS. In this mid-1890s photograph *Barge 101* (left) is tied up in the Soo Locks with her towing steamer of many years, the *Yakima*, at the right of the photograph. *Barge 101*, carrying less than 500 tons of cargo, was not only the first whaleback built but she was by far the smallest whaleback built. (Author's collection.)

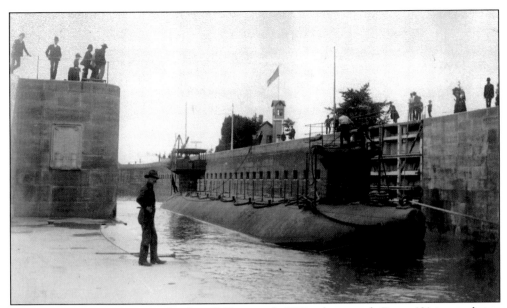

BARGE 101 AT THE SOO. In this late-1880s to early-1890s photograph *Barge 101* is seen being towed downbound out of the Weitzel Lock at the Soo. The dark color scheme (actually a brownish color) indicates that the barge was owned by the ASBC at the time the photograph was taken. ASBC owned *Barge 101* from 1888 to 1899. (Courtesy of the Judge Joseph H. Steere Room, Bayliss Public Library, Sault Sainte Marie, Michigan.)

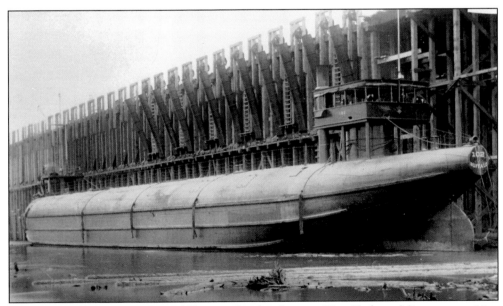

WHALEBACK BARGE 102. *Barge 102* sits under the chutes at Two Harbors, Minnesota, waiting for a load of iron ore sometime between July 1889 and April 1896. The iron ore, brought to the top of the structure by trains, would slide down the chutes (shown in their raised positions) into the holds of the barges. (Courtesy of the University of Detroit Mercy Special Collections, Fr. Edward J. Dowling, S. J. Marine Historical Collection.)

BILL OF LADING OF FIRST IRON ORE CARGO FROM THE MESABI RANGE

MESABI RANGE BILL OF LADING. This historic bill of lading contracts the first of many thousands of shipments of Mesabi Range iron ore to whaleback *Barge 102* in November 1892. The bill of lading reflects that *Barge 102* carried 2,073 tons of the Mesabi Range iron ore for $1.35 a ton from Superior, Wisconsin, to Cleveland for the Oglebay Norton Company. Interestingly, Alexander McDougall, as agent for *Barge 102*, signed the bill of lading as "Angus McDougall." The signature at the very bottom of the bill of lading is also interesting. Capt. Thomas Wilson signed the bill on November 30, 1892, as having received the shipment in good order. Wilson was a long-standing friend of McDougall's and was the namesake of the ill-fated whaleback steamer *Thomas Wilson*. (Courtesy of the Great Lakes Historical Society.)

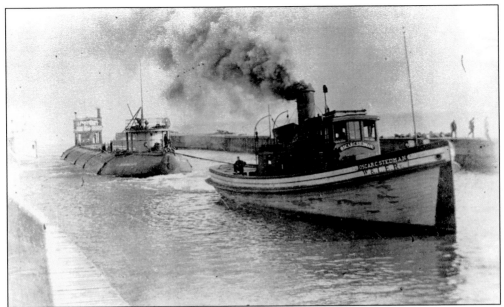

THE BARGE SIR JOSEPH WHITWORTH. The tug *Oscar C. Stedman* tows the barge *Sir Joseph Whitworth* (launched as *Barge 102* on July 17, 1889, from Duluth) sometime between June 1896 and April 1905 through one of the connecting waterways around the Great Lakes. Later named *Bath*, the barge sank south of Cape Charles, Virginia, on December 15, 1905, with the loss of six crewmen. (Courtesy of the Great Lakes Historical Society.)

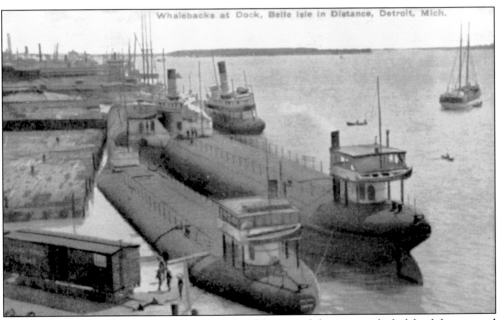

BARGES BATH AND BARAVIA AT DETROIT. An old postcard shows several whaleback barges and steamers tied up at Detroit in late 1905. The barge on the left is the *Baravia* (launched as *Barge 109* on November 15, 1890), while the barge on the right is the *Bath* (launched as *Barge 102* July 18, 1889). Both barges ended their days sinking along the eastern seaboard. (Courtesy of the Michigan Maritime Museum Collection.)

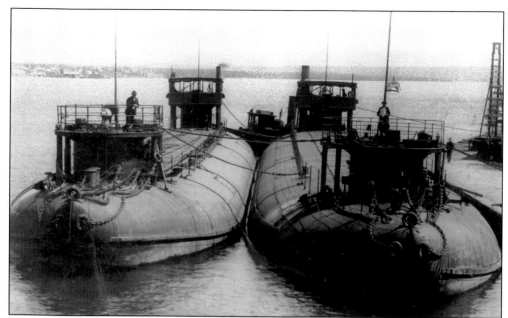

BARGE 102 AND BARGE 103. This photograph, taken between October 1889 and April 1896, shows *Barge 102* (left) and *Barge 103* (right) loaded and tied up at one of the docks in the Duluth, Minnesota, harbor. The barges were identical sisters, built within three months of each other at Duluth. (Courtesy of the University of Detroit Mercy Special Collections, Fr. Edward J. Dowling, S. J. Marine Historical Collection.)

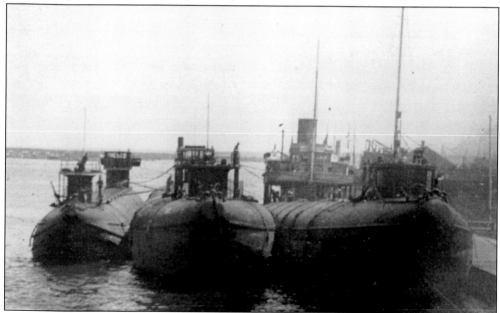

THREE WHALEBACKS AT DULUTH. *Barge 101* (left) and *Barge 103* (middle) are tied up to a Duluth Harbor dock alongside the steamer *Joseph L. Colby* (right) between November 1890 and April 1896. The relatively small size of *Barge 101* is evident compared to the other whalebacks that were built less than two years later. (Courtesy of the University of Detroit Mercy Special Collections, Fr. Edward J. Dowling, S. J. Marine Historical Collection.)

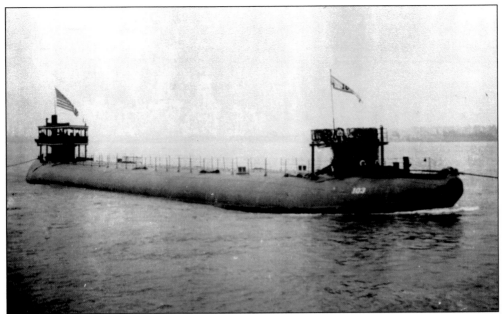

BARGE 103. *Barge 103* (launched on October 5, 1889, from Duluth, Minnesota) was the third whaleback constructed by Alexander McDougall. At 253 feet long, 36.1 feet wide, and with a draft of 18.8 feet, she was the identical sister ship of *Barge 102*. *Barge 103*'s first cargo was a load of 86,000 bushels of wheat from Duluth to Buffalo, New York, in October 1889. (Courtesy of the Historic Photo Collection/Milwaukee Public Library.)

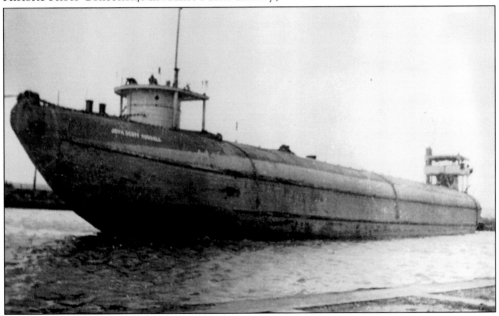

JOHN SCOTT RUSSELL UNDER TOW. This photograph, dated between June 1896 and March 1905, shows the *John Scott Russell* (launched as *Barge 103*) being towed into one of the locks at the Soo. The barge, under her third and final name, *Berkshire*, sank off Sandy Hook, New Jersey, on May 23, 1909. (Courtesy of the University of Detroit Mercy Special Collections, Fr. Edward J. Dowling, S. J. Marine Historical Collection.)

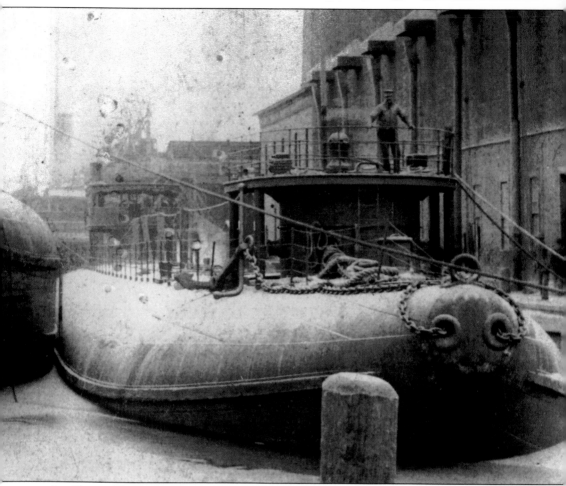

AN EARLY PHOTOGRAPH OF BARGE 104. *Barge 104* was the fourth whaleback built by Capt. Alexander McDougall, launched on February 6, 1890, from Duluth, Minnesota, and became the first whaleback vessel wrecked on the Great Lakes. Very late on the evening of November 10, 1898, *Barge 104* was being towed out of the Cleveland harbor behind the tug *Alva B.* during a heavy storm. *Barge 104's* towline parted and she slammed into the harbor's west breakwater approximately one half mile northwest of Cleveland's U.S. Life Saving Service station. The U.S. Life Saving Service crew was alerted to the accident and responded quickly to the scene in their English lifeboat. Due to the high seas the U.S. Life Saving Service crew was unable to secure a line to the barge. The U.S. Life Saving Service crew pulled their boat inside the breakwater and then worked with ropes and heaving sticks to help the barge's crew off the boat and onto the breakwater. Thankfully there were no injuries but *Barge 104* was a total loss. (Courtesy of the University of Detroit Mercy Special Collections, Fr. Edward J. Dowling, S. J. Marine Historical Collection.)

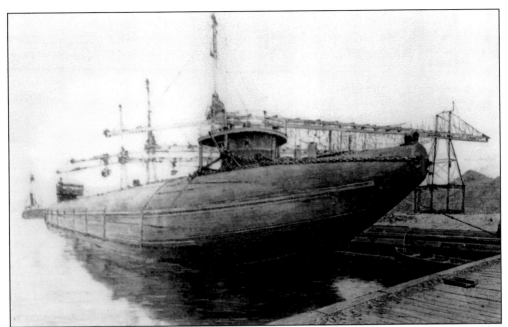

BARGE 104. In this 1890s photograph, *Barge 104* is shown loading coal at one of the ports on the lower lakes. *Barge 104* was launched on February 6, 1890, from Duluth. She was 276.5 feet long and had a 36.1 foot beam. (Courtesy of the University of Detroit Mercy Special Collections, Fr. Edward J. Dowling, S. J. Marine Historical Collection.)

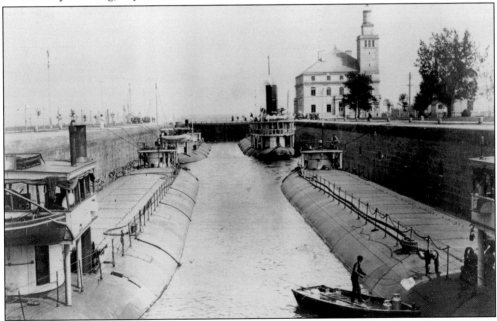

A GATHERING OF WHALEBACKS. *Barge 104* (foreground left) and three other whalebacks are shown in the Weitzel Lock at the Soo during the 1890s. The unidentified steamer (background right) is towing all three of the barges, a not uncommon practice in the late 19th century. (Courtesy of the University of Detroit Mercy Special Collections, Fr. Edward J. Dowling, S. J. Marine Historical Collection.)

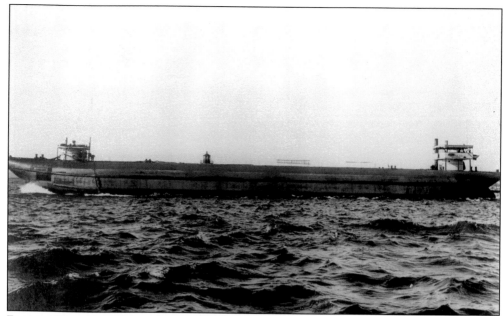

BARGE 105 ON THE GREAT LAKES. This photograph shows *Barge 105* under tow on the Great Lakes between April 1890 and March 1905. *Barge 105*, launched on April 22, 1890, from Duluth, Minnesota, was 276.5 feet long with a beam of 36 feet. (Courtesy of the University of Detroit Mercy Special Collections, Fr. Edward J. Dowling, S. J. Marine Historical Collection.)

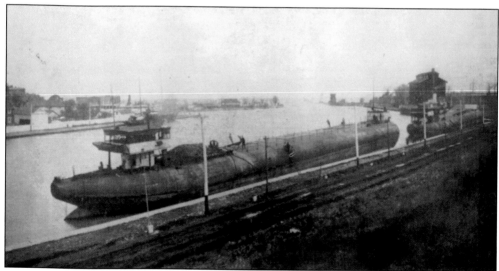

BARGE 105. *Barge 105* (foreground) was renamed *Baroness* in 1905 and went to the Atlantic coast coal trade in 1908. On November 10, 1910, while being towed by the whaleback steamer *Bay Port* 15 miles southwest of the *Fire Island Light Ship*, the *Baroness* was rammed and sunk by the French registered bark *Elisabeth*. (Courtesy of the University of Detroit Mercy Special Collections, Fr. Edward J. Dowling, S. J. Marine Historical Collection.)

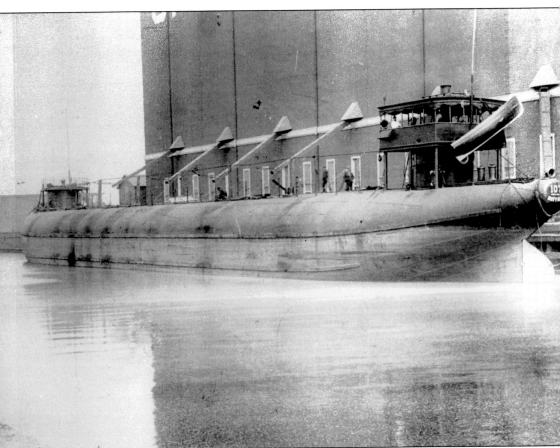

BARGE 107 AT DULUTH. In this 1890s photograph, *Barge 107* is shown waiting for a load of grain at the Great Northern "A" grain elevator in Duluth, Minnesota. *Barge 107*, launched on August 16, 1890, was the last whaleback built in Capt. Alexander McDougall's Duluth shipyard before the ASBC operation moved across the harbor to Superior, Wisconsin. *Barge 107* was 276.5 feet long, 36 feet of beam, had a draft of 18.75 feet, and could carry 3,000 tons of bulk cargo in her hold. In her first sailing season, 1890, *Barge 107* had the distinction of carrying the largest cargo of the entire year through the Soo Locks—3,021 tons of grain. *Barge 107* was renamed *Bombay* in 1905 and, in 1908, she was sent to the Atlantic seaboard to work the coastal coal trade. *Bombay* sank near Nantucket Shoals on January 3, 1913, during an Atlantic gale. Thankfully, *Bombay*'s seven-man crew was rescued. (Courtesy of the University of Detroit Mercy Special Collections, Fr. Edward J. Dowling, S. J. Marine Historical Collection.)

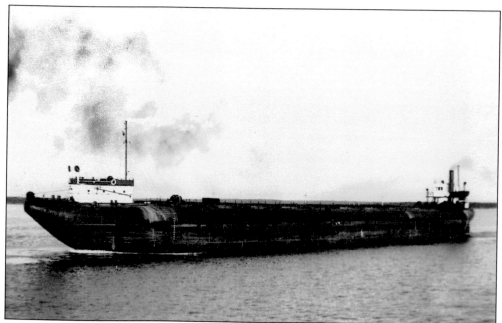

BARGE 107. *Barge 107* (renamed *Bombay* in 1905) had a relatively accident-free career on the lakes, but after her transfer to the Atlantic in 1908 all manner of problems befell her. In January 1911, *Bombay* sank at her Boston dock after a collision. In February 1912, her captain, Oli Aaroson, was swept overboard off Virginia. On January 3, 1913, *Bombay* sank at Nantucket Shoals during a winter storm. (Author's collection.)

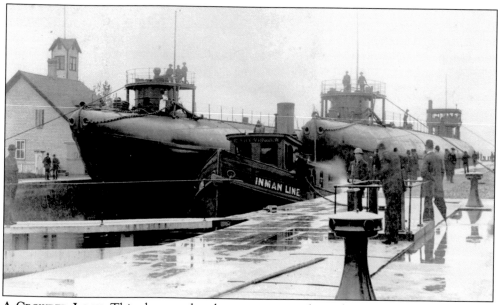

A CROWDED LOCK. This photograph, taken sometime in the early 1900s, shows the tug *Mary Virginia* towing one of two whaleback barges out of the locks at the Soo. It is very probable that the tug was towing both barges as a two barge configuration was very common in that era. (Courtesy of the Historic Photo Collection/Milwaukee Public Library.)

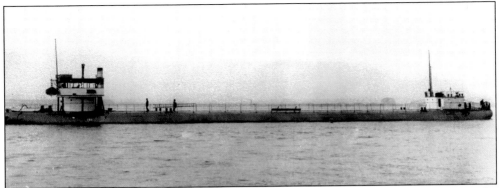

BARGE 109. This 1890s to early-1900s photograph shows *Barge 109* loaded and under tow on the Great Lakes. In 1905, *Barge 109* was renamed *Baravia* and sent to work the Atlantic coast coal trade. *Baravia* sank off Montauk Point, New York, on January 23, 1914. Thankfully her entire five-man crew was saved. (Courtesy of the University of Detroit Mercy Special Collections, Fr. Edward J. Dowling, S. J. Marine Historical Collection.)

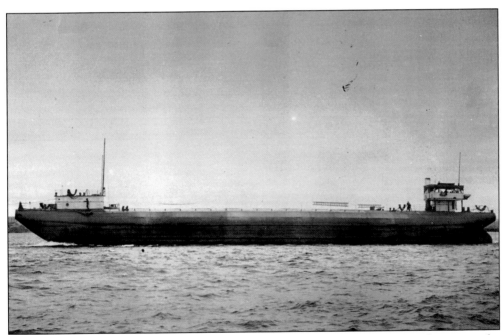

BARGE 110 UNDER WAY. This very-early-1900s photograph shows *Barge 110* under tow on the Great Lakes. *Barge 110*, whose launch was witnessed by more than 10,000 people on April 28, 1891, had the ability to carry 83,000 bushels of wheat (approximately 2,500 gross tons) in her hold. (Courtesy of the University of Detroit Mercy Special Collections, Fr. Edward J. Dowling, S. J. Marine Historical Collection.)

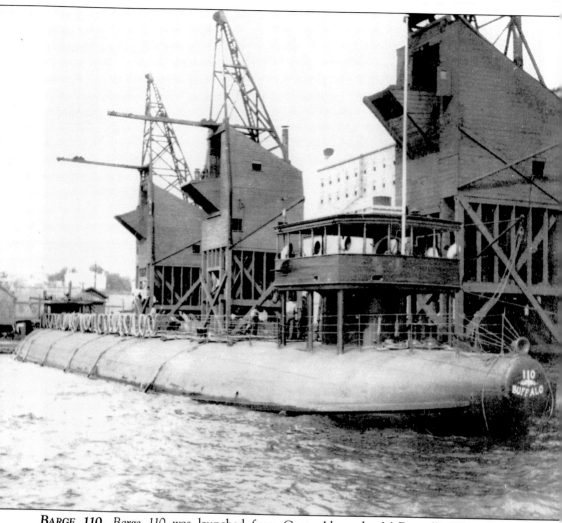

BARGE 110. *Barge 110* was launched from Capt. Alexander McDougall's West Superior, Wisconsin, shipyard on April 28, 1891. *Barge 110*, the sister ship of *Barge 109* and *Barge 111*, was 265 feet long, had a beam of 36 feet, and a draft of 22 feet. She was renamed *Badger* in March 1905 and then renamed *Pure Lubewell* in September 1927. During her 41-year career the barge had 10 different owners and sailed on the Great Lakes for the iron ore and coal trade, the Atlantic seaboard for the coal trade, and the Gulf of Mexico in the petroleum transport business. On March 3, 1932, while tied up on the Mississippi River at the Cities Service Export Oil Company dock at St. Rose, Louisiana, the *Pure Lubewell* suffered an explosion and subsequent fire that killed one crewman and destroyed the barge. (Courtesy of the University of Detroit Mercy Special Collections, Fr. Edward J. Dowling, S. J. Marine Historical Collection.)

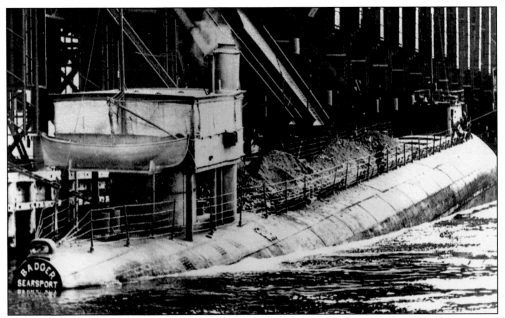

BADGER LOADING COAL. The barge *Badger*, launched as *Barge 110*, is shown in this photograph from between 1905 and 1927 loading coal into her hold. The single lifeboat all whaleback barges carried behind their pilothouses (during the early years of their sailings) is clearly visible. The lifeboats were the only lifesaving equipment aboard the whaleback barges with the exception of the crew's individual life preservers. (Author's collection.)

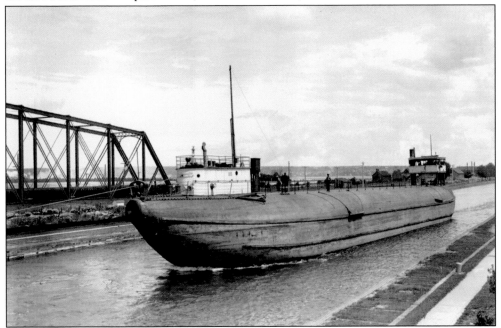

BARGE 111 IN THE WELLAND CANAL. This photograph, taken between March 1900 and February 1905, shows *Barge 111* being towed light along the Welland Canal. *Barge 111* was launched on April 28, 1891, at West Superior, Wisconsin, and was 265 feet long, 36 feet wide, and had a draft of 22 feet. (Courtesy of the Great Lakes Historical Society.)

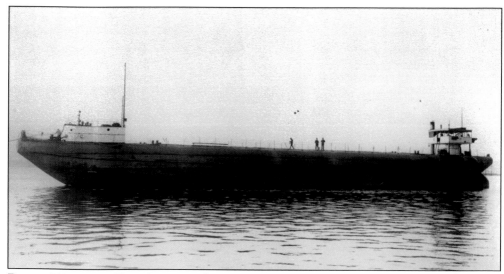

BARGE 111 UNDER TOW. *Barge 111*, the sister ship of *Barge 109* and *Barge 110*, is shown under tow in this early-1900s photograph. She was the second of the two barges launched by the ASBC at West Superior, Wisconsin, on April 28, 1891. (Courtesy of the University of Detroit Mercy Special Collections, Fr. Edward J. Dowling, S. J. Marine Historical Collection.)

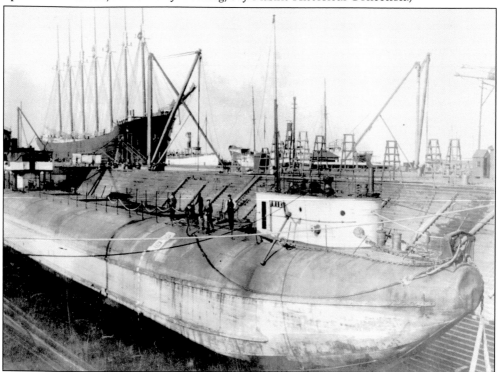

THE IVIE IN DRY DOCK. The barge *Ivie*, launched as *Barge 111*, is shown in dry dock sometime between June 1905 and March 1910, while owned by the Baltimore and Boston Barge Company. On May 10, 1916, *Ivie* was rammed by the steamer *Berkshire* at Hampton Roads, Virginia, and sank with her crew being rescued. (Courtesy of the University of Detroit Mercy Special Collections, Fr. Edward J. Dowling, S. J. Marine Historical Collection.)

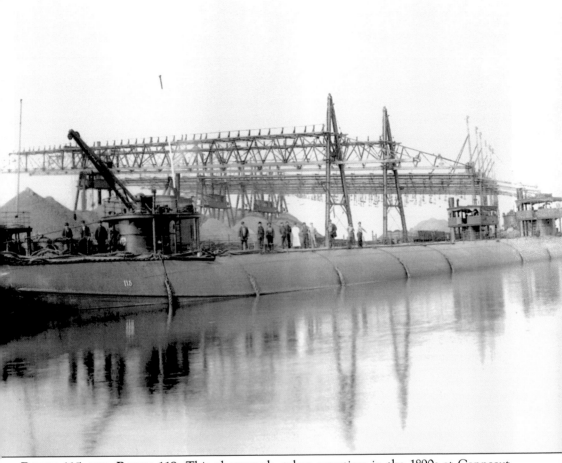

BARGE 115 AND BARGE 118. This photograph, taken sometime in the 1890s at Conneaut, Ohio, shows two whaleback barges, *Barge 115* in the foreground and *Barge 118* behind, tied up at the dock. *Barge 115* and her eight-man crew were hurled into a life and death struggle in December 1899 when, while being towed by the whaleback steamer *Colgate Hoyt* from Tow Harbors, Minnesota, to Lake Erie, the towline parted south of Pic Island during a Lake Superior gale. The *Colgate Hoyt*, despite frantic efforts, lost sight of *Barge 115* in the storm. *Barge 115* and her crew were banged and battered and buffeted by the lake's storm waters for five days before the barge finally fetched up on Pic Island. The crew scrambled off the sinking barge but found themselves still not on the mainland. The crew fashioned a raft out of wood found on the island and sailed to the Canadian shore some three miles away then walked for several days in the knee deep snow before being found by a railroad crew. (Author's collection.)

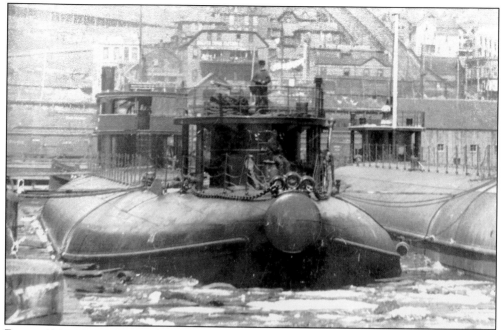

BARGE 116 AT DULUTH. In this 1890s photograph, *Barge 116* is shown during the spring season in the Duluth Harbor with the hillside town rising up behind her. The famous Duluth incline can be seen running up and down the hill to the right of the barge. (Courtesy of the University of Detroit Mercy Special Collections, Fr. Edward J. Dowling, S. J. Marine Historical Collection.)

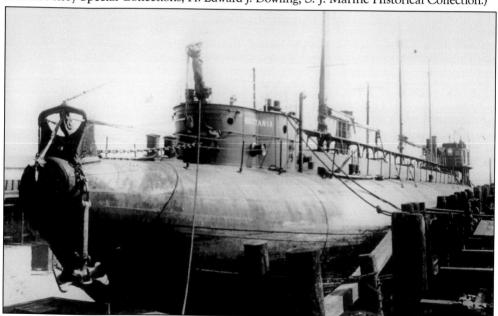

THE BARGE BRITTANIA. The *Britannia* was launched as *Barge 116* on August 29, 1891, from West Superior, Wisconsin. She was renamed *Brittania* in 1905 and was again renamed *Pure Tiolene* in 1927. She was a work-a-day barge that ended her days being scrapped in 1946 at Port Arthur, Texas, after a 55-year sailing career. (Courtesy of the University of Detroit Mercy Special Collections, Fr. Edward J. Dowling, S. J. Marine Historical Collection.)

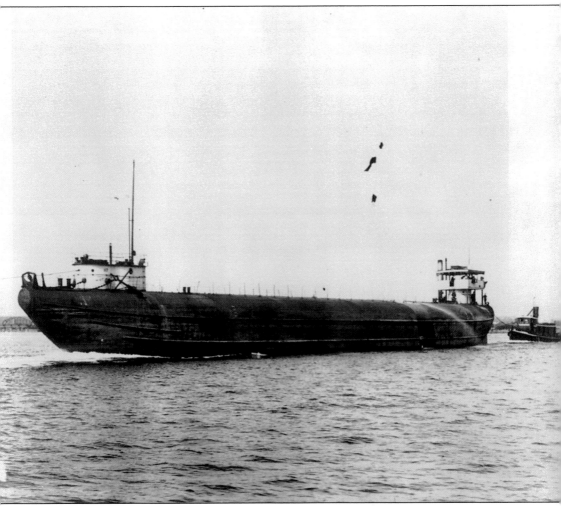

BARGE 117 UNDER TOW. *Barge 117* was launched on Saturday, November 14, 1891, from the ASBC shipyard at West Superior, Wisconsin. She was the 14th whaleback barge constructed and was the identical sister ship of *Barge 118* launched less than a month later. *Barge 117* was 285 feet long with a beam of 36 feet and a draft of 22 feet. *Barge 117* sailed the Great Lakes under four different owners from 1891 through 1911. Under the ownership of the Philadelphia Trust, Safe Deposit and Insurance Company, she was sent to the Atlantic seaboard to work the coastal coal routes and her name was changed to *Providence*. While sailing the East Coast, *Providence* had six owners in the 18 years she hauled coal. In April 1929, *Providence* was sold by her last American owner, the Petroleum Navigation Company, to a British concern and the barge basically disappeared as there is no record of her registration anywhere after the sale. (Courtesy of the University of Detroit Mercy Special Collections, Fr. Edward J. Dowling, S. J. Marine Historical Collection.)

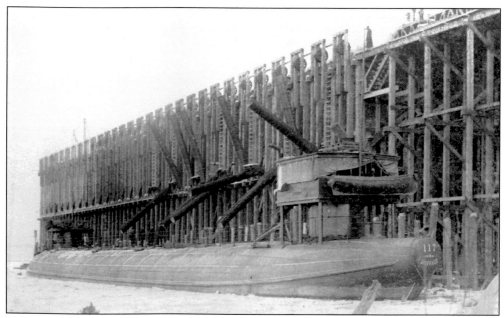

BARGE 117 LOADING IRON ORE. This 1890s photograph shows *Barge 117* loading iron ore from a Lake Superior gravity dock. Iron ore was the staple cargo for many years for most of the Great Lakes whaleback barges and ore laden barges made thousands of trips from the Duluth-Superior area to the lower lakes. (Courtesy of the University of Detroit Mercy Special Collections, Fr. Edward J. Dowling, S. J. Marine Historical Collection.)

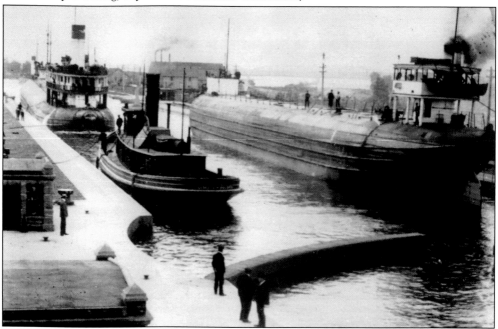

BARGE 118 AT THE SOO. *Barge 118* (right) is shown with her tow, a whaleback steamer (left), and a tug (center) at the Soo Locks in the very early 1900s. *Barge 118* was launched on December 5, 1891, and was 285 feet long, 36 feet wide, and had a draft of 22 feet. (Courtesy of the University of Detroit Mercy Special Collections, Fr. Edward J. Dowling, S. J. Marine Historical Collection.)

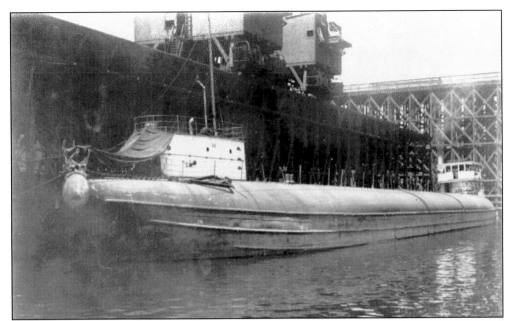

BARGE 118. This photograph, taken between April 1892 and March 1911, shows *Barge 118* tied up at a Great Lakes dock awaiting a load of iron ore. In her 55 years of sailing the Great Lakes and the Gulf of Mexico, *Barge 118* had 10 different owners and six different names. She was scrapped at Port Arthur, Texas, in 1946. (Courtesy of the Historic Photo Collection/Milwaukee Public Library.)

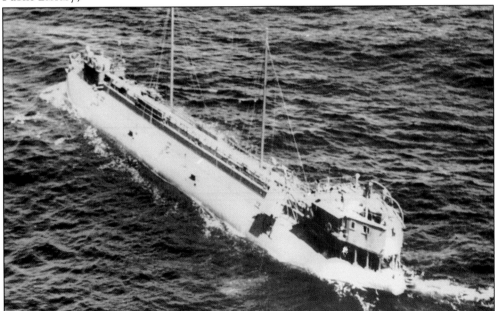

PURE DETONOX IN THE GULF OF MEXICO. This photograph of *Pure Detonox* (launched as *Barge 118* on December 5, 1891, at West Superior, Wisconsin) was used by the American armed services during World War II to identifying the barge as friendly as she sailed the Gulf of Mexico transporting bulk petroleum. (Courtesy of the University of Detroit Mercy Special Collections, Fr. Edward J. Dowling, S. J. Marine Historical Collection.)

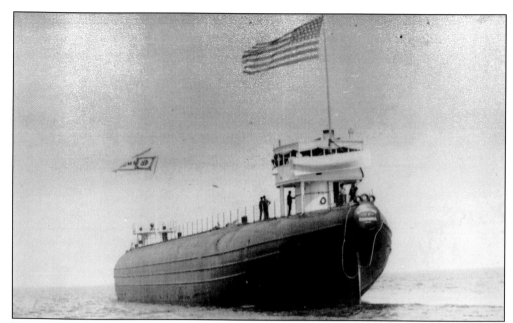

THE BARGE SAGAMORE AT SUPERIOR. The barge *Sagamore* sits outside Superior, Wisconsin, just weeks after her launching on July 23, 1892. The *Sagamore* sank on July 29, 1901, after being rammed by the steamer *Northern Queen* in Whitefish Bay, Lake Superior. Her captain and two other crewmen died in the accident. (Courtesy of the Historic Photo Collection/Milwaukee Public Library.)

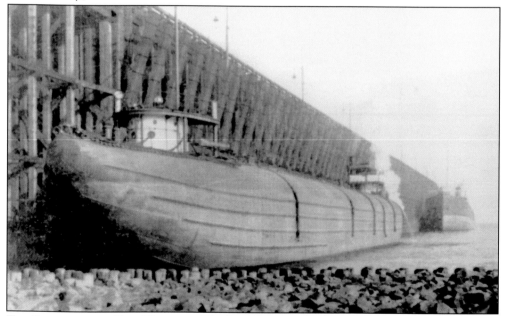

THE SAGAMORE AT TWO HARBORS. The barge *Sagamore* is loading iron ore at Two Harbors, Minnesota, sometime between July 1892 and July 1901. The *Sagamore* was 308 feet long with a 38 foot beam and a draft of 24 feet and could carry 3,600 tons of bulk cargo in her hold. (Courtesy of the University of Detroit Mercy Special Collections, Fr. Edward J. Dowling, S. J. Marine Historical Collection.)

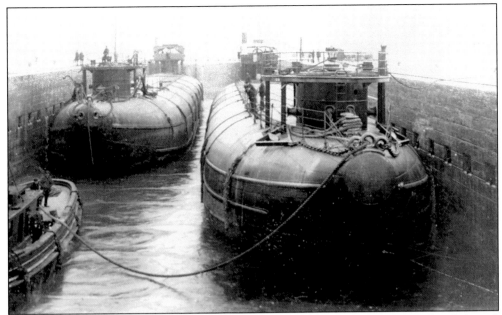

BARGE 126 AT THE SOO. *Barge 126* (right) and an unidentified whaleback barge (left rear) are being towed through the Soo Locks by a tug sometime between 1893 and 1900. *Barge 126* went to the Atlantic seaboard in 1905 and was wrecked in Buzzards Bay, Massachusetts, on December 31, 1905. (Courtesy of the University of Detroit Mercy Special Collections, Fr. Edward J. Dowling, S. J. Marine Historical Collection.)

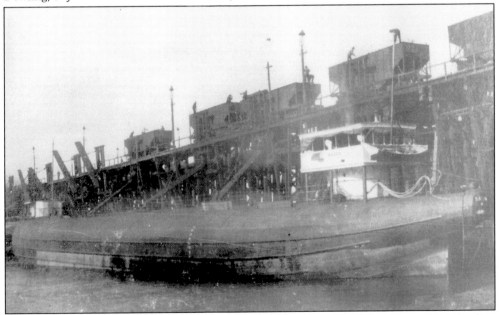

THE BARGE BADEN. The barge *Baden*, launched on December 17, 1892, as *Barge 126*, is loading iron ore from a gravity-fed ore dock in 1905. On December 31, 1905, the *Baden* was wrecked off the Atlantic coast while carrying coal from Virginia to Massachusetts with the loss of all six members of her crew. (Courtesy of the University of Detroit Mercy Special Collections, Fr. Edward J. Dowling, S. J. Marine Historical Collection.)

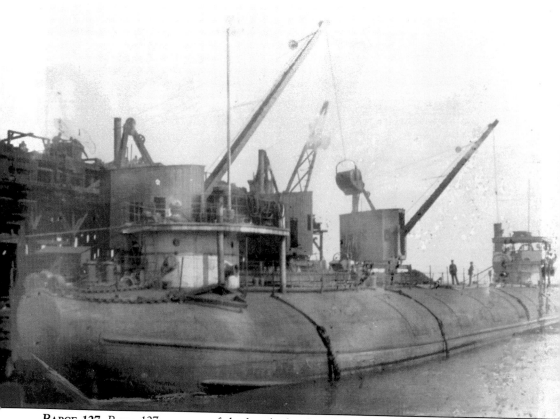

BARGE 127. *Barge 127* was one of the hundreds of work-a-day boats on the Great Lakes and along America's seaboards that attracted little attention and no fanfare as she moved bulk cargo from port to port. *Barge 127* was launched on October 29, 1892, and, at 264 feet long, 38 feet abeam, and with a 22-foot draft, was the identical twin of *Barge 126*. During her 44-year sailing career *Barge 127* was owned by six different companies, her name was changed twice (to *Jeannie* in February 1905 and to *Dallas* in October 1907), and she sailed not only on the Great Lakes but along the Atlantic coast and in the Gulf of Mexico. She was altered to a schooner barge with two masts in 1907 with a slight increase in her gross and net tonnage. In 1936, *Dallas* was abandoned and subsequently scrapped. Her documents were surrendered in late 1936 at New Orleans, Louisiana. (Courtesy of the University of Detroit Mercy Special Collections, Fr. Edward J. Dowling, S. J. Marine Historical Collection.)

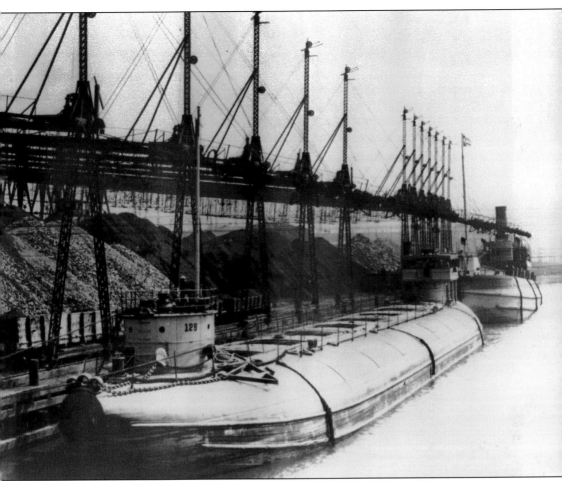

BARGE 129 AT CLEVELAND. *Barge 129* is shown tied up at the docks at Cleveland awaiting a load of coal around 1895. Unfortunately *Barge 129* had a very short sailing career. She was launched from West Superior, Wisconsin, on May 13, 1893, and went into service for the ASBC until March 1900, when she was purchased by the Bessemer Steamship Company. A year later, in June 1901, the Bessemer fleet was rolled into the gigantic Pittsburgh Steamship Company and *Barge 129* sailed under the colors of that great company. On October 13, 1902, while being towed by the steamer *Maunaloa* during a fall storm on Lake Superior approximately 30 miles northwest of Vermilion Point, Michigan, *Barge 129*'s towline broke away. While the crews of the two boats attempted to reconnect the towline the anchor of the *Maunaloa* punctured several of *Barge 129*'s hull plates. The barge filled with water and sank very quickly. Thankfully the entire crew of *Barge 129* was able to scramble to safety aboard the *Maunaloa*. (Courtesy of the Great Lakes Historical Society.)

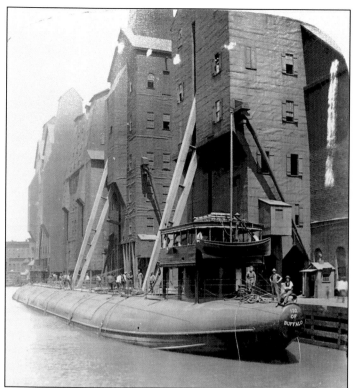

BARGE 130. This 1890s photograph shows *Barge 130* loading grain from one of the many terminals around the Great Lakes. *Barge 130* was one of six identical barges (*Barge 129–Barge 134*) in the 292-foot subclass, all launched in the summer of 1893. They were the only whalebacks built by the ASBC in 1893. (Courtesy of the University of Detroit Mercy Special Collections, Fr. Edward J. Dowling, S. J. Marine Historical Collection.)

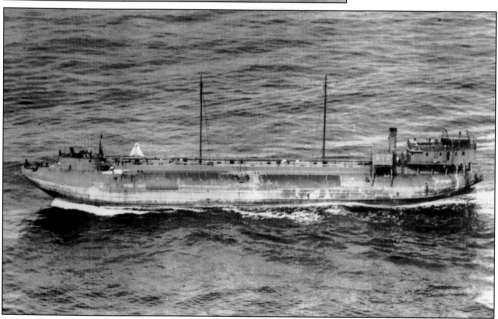

PURE NULUBE. This photograph was one of the ship identification photographs used by the United States military during World War II to help identify vessels sailing in American waters. The *Pure Nulube* (launched as *Barge 131* on June 17, 1893) is seen in her role as a petroleum transporter during the war. (Courtesy of the University of Detroit Mercy Special Collections, Fr. Edward J. Dowling, S. J. Marine Historical Collection.)

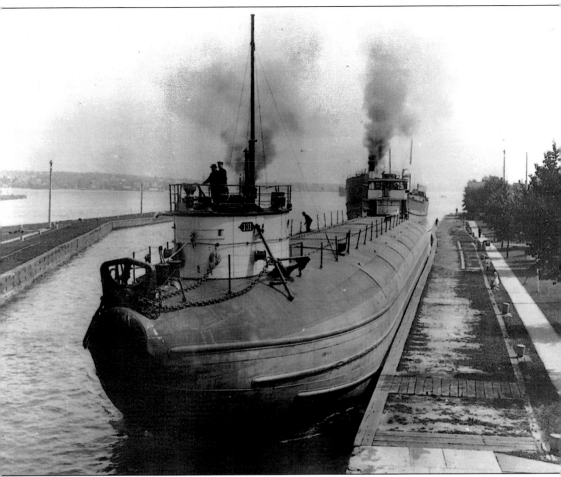

BARGE 131 AT THE SOO. Whaleback *Barge 131* is shown running upbound at the Soo Locks sometime between March 1900 and April 1911. *Barge 131* was launched on June 3, 1893, and was 292 feet long, 36 feet wide, and had a 22-foot draft. Just prior to her 1912 move to the Atlantic coast to work in the New England coal trade, the barge was shortened 31 feet by the Great Lakes Engineering Works with a decrease in her gross tonnage to 1,159 and a decrease of her net tonnage to 1,115. During her 53 years on the waves, *Barge 131* had five different names (including the name she had in the late 1920s that was the longest name ever attached to any whaleback, *Pure Oil Steamship Company Barge No. 10*) and sailed under 11 different owners. The barge, under her last name, *Pure Nulube*, was abandoned and subsequently scrapped at Houston, Texas, in 1946 with her documents being surrendered at Port Arthur, Texas, that same year. (Author's collection.)

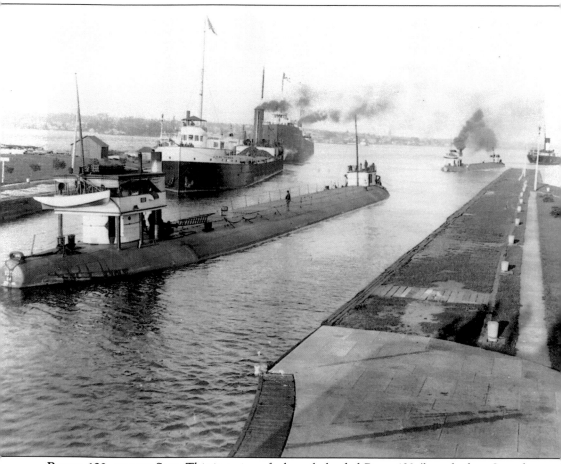

BARGE 132 AT THE SOO. This is a view of a heavily loaded *Barge 132* (launched on Saturday, June 17, 1893, at West Superior, Wisconsin) as the second tow in a two barge line being pulled downbound out of the Davis/Sabin Lock at the Soo Locks sometime between 1900 and 1911. *Barge 132* was 292 feet long, 36 feet abeam, and had a 22-foot draft. During her 34-year career, the barge sailed under 10 different owners, but had only two names: initially *Barge 132* and, after March 21, 1911, *Portsmith*. On Saturday, October 1, 1927, while carrying a hold full of crude oil and in the tow of the tug *El Pelicano*, the *Portsmith* ran into a storm in the Gulf of Mexico, began to leak and subsequently sank some 15 miles southwest of Freeport, Texas, with no loss of life. (Author's collection.)

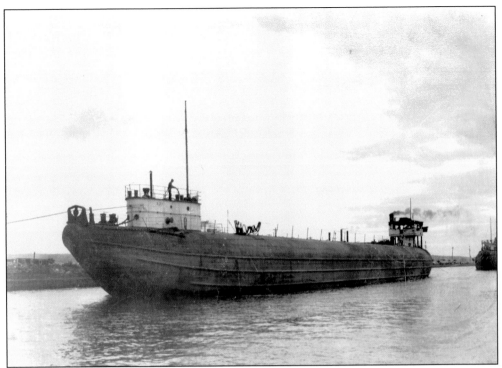

BARGE 133. *Barge 133*, launched on Saturday, June 17, 1893, at West Superior, Wisconsin, was one of the six barges in the 292-foot subclass. This photograph, taken between March 1900 and April 1911, shows *Barge 133* being towed through the Welland Canal as the first barge in a two barge tow. (Courtesy of the Great Lakes Historical Society.)

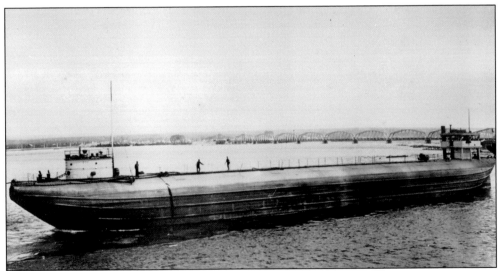

BARGE 133 UNDER TOW. *Barge 133* is shown in this early-1900s photograph under tow in one of the Great Lakes ports. Renamed *Searsport* in 1911, she was sent to the Atlantic coast and sank south of Fire Island, New York, on November 11, 1911, with the loss of all five crewmen. (Courtesy of the University of Detroit Mercy Special Collections, Fr. Edward J. Dowling, S. J. Marine Historical Collection.)

BARGE 134 DOCKED. *Barge 134* was the last of the six sister barges to be launched by the ASBC in 1893. Construction of the barge began on February 25, 1893, and she was in the water on June 10, 1893, less than four months later. In this early-1900s photograph, *Barge 134* waits at one of the Great Lakes docks for her towing steamer to load. *Barge 134* sailed the Great Lakes until 1911 when she was renamed *Bangor* and sent to the Atlantic seaboard to be towed up and down the coast in the coal trade. Unfortunately *Bangor* had a very short career on the Atlantic Ocean. On December 7, 1912, the *Bangor* was involved in a collision with the steamer *Essex* at Hampton Roads, Virginia. The barge was beached and subsequently declared a total loss. Thankfully none of the *Bangor*'s crew was lost during the incident. (Courtesy of the University of Detroit Mercy Special Collections, Fr. Edward J. Dowling, S. J. Marine Historical Collection.)

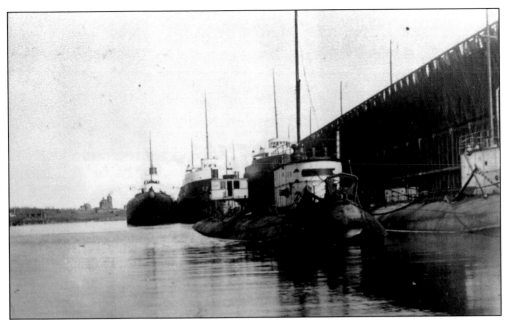

BARGES AWAITING A TOW. *Barge 134* (center front) and several boats, including two whalebacks, wait at one of the huge ore docks that dotted the Great Lakes in the early 1900s. The large dent on the bow of *Barge 134* attests to the rough handling the barges withstood year after year while sailing the lakes. (Courtesy of the University of Detroit Mercy Special Collections, Fr. Edward J. Dowling, S. J. Marine Historical Collection.)

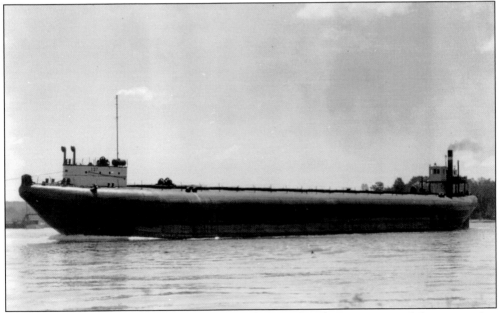

BARGE 137. This photograph shows *Barge 137* light and under tow on one of the connecting waterways of the Great Lakes. *Barge 137* had the distinction of being the longest-serving whaleback barge in history—69 years, four months—edging out the *Alexander Holley* for that honor by just three months. (Courtesy of the Historic Photo Collection/Milwaukee Public Library.)

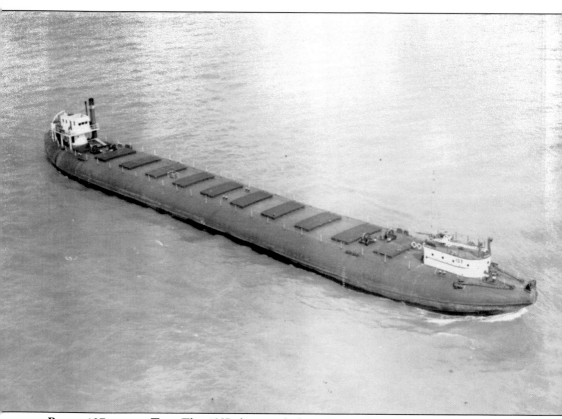

BARGE 137 UNDER TOW. This 1937 photograph shows *Barge 137* under tow on calm waters. She was launched on Saturday, May 9, 1896, at West Superior, Wisconsin. *Barge 137* was 345.5 feet long with a beam of 45.5 feet and a draft of 26 feet. *Barge 137* had 11 hatches on 24-foot centers that led to her three cargo compartments. Each compartment held 1,700 tons of cargo for a total of 5,100 tons of bulk cargo in her holds. During her 69 years of sailing the Great Lakes *Barge 137* had 11 different owners—initially American and at the end of her career Canadian—but retained her original name throughout her days. *Barge 137*, after being used for grain storage at Goderich, Ontario, for several years, was scrapped at Hamilton, Ontario, in the summer of 1965. Her Canadian registry was closed on September 16, 1965. (Courtesy of the Historic Photo Collection/Milwaukee Public Library.)

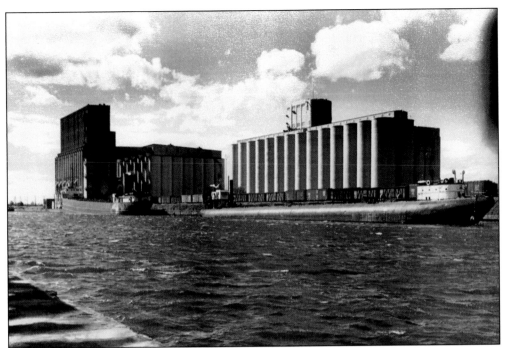

BARGE 137 AT PORT WILLIAM. This photograph shows *Barge 137* (right) loading grain at the elevators at Port William, Ontario, on June 10, 1952. *Barge 137* was a grain carrier during the majority of her sailing days and could carry 175,000 bushels of grain in her three holds. (Courtesy of the Great Lakes Historical Society.)

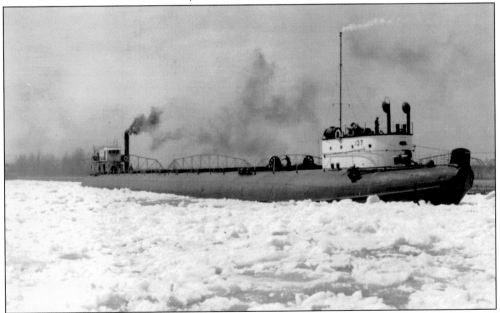

BARGE 137 IN ICE. This photograph shows *Barge 137* being towed through the ice on one of the connecting waterways of the Great Lakes at the end of the 1939 shipping season. Because of their snoutlike bows, the whaleback barges took the ice very well. (Courtesy of the Historic Photo Collection/Milwaukee Public Library.)

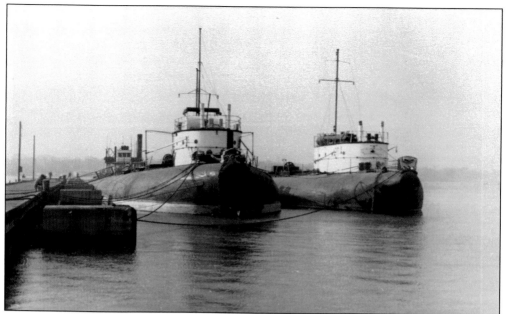

WHALEBACK BARGES AT SARNIA, ONTARIO. The barges *Alexander Holley* (left) and *Barge 137* (right) are tied up at Sarnia, Ontario, on November 16, 1954. The two vessels were the largest whaleback barges ever constructed with the *Alexander Holley* being 377 feet long while *Barge 137* was 345.5 feet long. Both had exceedingly long and distinguished careers sailing the Great Lakes. (Courtesy of the Great Lakes Historical Society.)

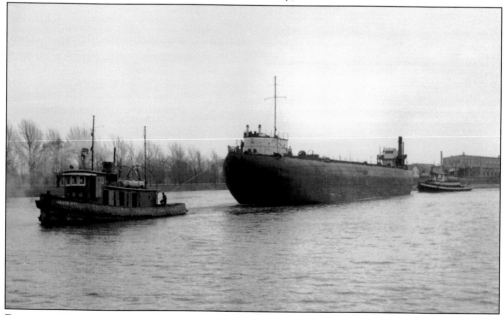

BARGE 137'S LAST TRIP. This May 1965 photograph shows *Barge 137* on the last trip of her remarkable 69-year sailing career. Sadly the two tugs are taking *Barge 137* to the Strathearne Terminals in Hamilton, Ontario, where she was scrapped. *Barge 137*'s final Canadian registry was closed on September 16, 1965. (Courtesy of the University of Detroit Mercy Special Collections, Fr. Edward J. Dowling, S. J. Marine Historical Collection.)

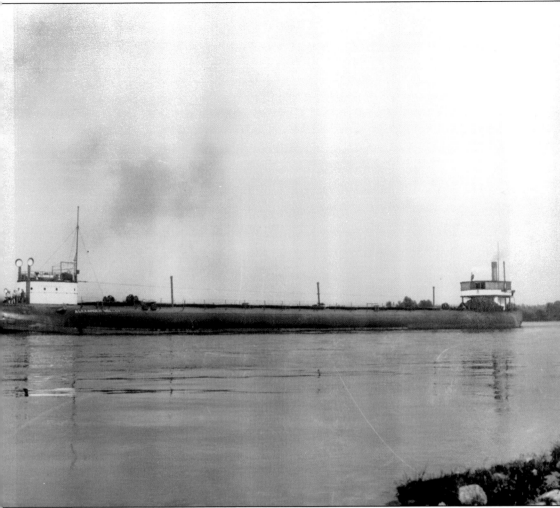

THE LAST WHALEBACK BARGE. In this mid-1930s photograph, the barge *Alexander Holley* is shown under tow on one of the many connecting waterways of the Great Lakes. The *Alexander Holley* had the distinction of being the last whaleback barge ever built. She was launched on August 12, 1896, at West Superior, Wisconsin. The *Alexander Holley* was not only the last whaleback barge ever built but she was also the largest whaleback barge ever built—more than twice the length of *Barge 101* built just eight years earlier. At 377 feet long, 46 feet wide, and having a draft of 22 feet, the *Alexander Holley* could carry 5,700 tons of bulk cargo in her three cargo holds. For most of her 69-year Great Lakes sailing career the *Alexander Holley* was towed behind the whaleback steamer *John Ericsson*. Over many years, the *Alexander Holley* and the *John Ericsson* remained a team through many American and Canadian owners. The *Alexander Holley* was scrapped at Hamilton, Ontario, in the summer of 1965. (Courtesy of the Historic Photo Collection/Milwaukee Public Library.)

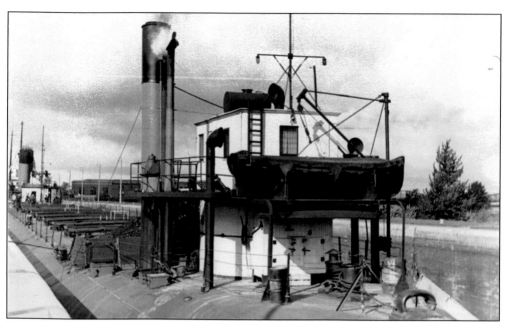

THE PILOTHOUSE OF THE ALEXANDER HOLLEY. This photograph, taken on September 25, 1946, at the Soo Locks, shows the detail of the barge *Alexander Holley*'s pilothouse as it sits atop the aft turret. The pilothouse had been fully enclosed by the time this photograph was taken—a far cry from the open-air pilothouse that was first on the boat. (Courtesy of the Historic Photo Collection/Milwaukee Public Library.)

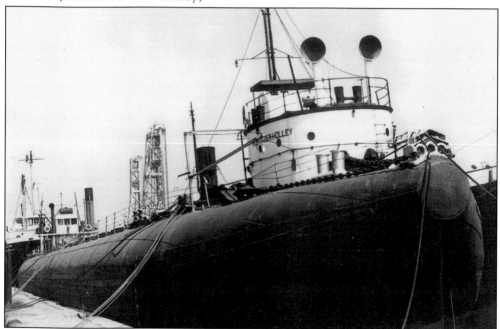

THE BARGE ALEXANDER HOLLEY. In this mid-1940s photograph the barge *Alexander Holley* is shown tied up at one of the Great Lakes ports. The air scoops atop the bow turret funneled fresh air down to the rather dark and damp crew quarters located just below the turret. The bow turret housed winches and a windless for raising the barge's anchor. (Author's collection.)

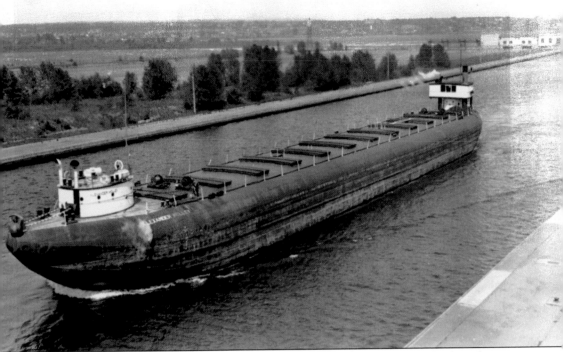

THE ALEXANDER HOLLEY UNDER TOW. The very well traveled and extremely long lasting barge *Alexander Holley* is seen being towed on the Welland Canal in this 1939 photograph. The *Alexander Holley* and her towing steamer, the *John Ericsson*, were one of the longest continuously sailing steamer/barge teams in Great Lakes history. The *John Ericsson* towed the *Alexander Holley* exclusively from 1896 through the 1930s. Even after the early 1940s, the *John Ericsson* towed the *Alexander Holley* on a regular basis. The *Alexander Holley* had 11 different owners over her astonishing 69-year Great Lakes sailing career but kept her original name throughout each ownership change. Before being scrapped in 1965, the *Alexander Holley* served for several years as a floating grain storage facility at Goderich, Ontario. The final documents for the *Alexander Holley* were surrendered on September 16, 1965. (Courtesy of the Historic Photo Collection/Milwaukee Public Library.)

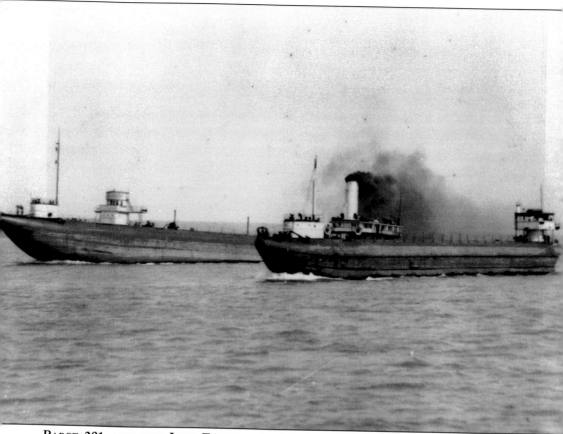

BARGE 201 AND THE JOHN ERICSSON. In this photograph, taken between 1896 and 1908, *Barge 201* and the whaleback steamer *John Ericsson* are shown side by side. *Barge 201*, launched on April 30, 1890, was built to Capt. Alexander McDougall's specifications by the Handren and Robins Atlantic Dock Company in Brooklyn, New York. *Barge 201* was 182 feet long, with a 32.2-foot beam, and a draft of 16.6 feet. The barge sailed the Atlantic seaboard very briefly and then came to work on the Great Lakes. During the winter of 1896–1897 *Barge 201* was lengthened by the ASBC at West Superior, Wisconsin, to 244 feet long. *Barge 201* was renamed *Cassie* in February 1905 and returned to the Atlantic coast in 1908 to ply the coastal coal trade. On October 24, 1917, during heavy weather, the *Cassie* was stranded at Sandy Hook, New Jersey, and declared a total loss. Thankfully her five-man crew was rescued. (Courtesy of the University of Detroit Mercy Special Collections, Fr. Edward J. Dowling, S. J. Marine Historical Collection.)

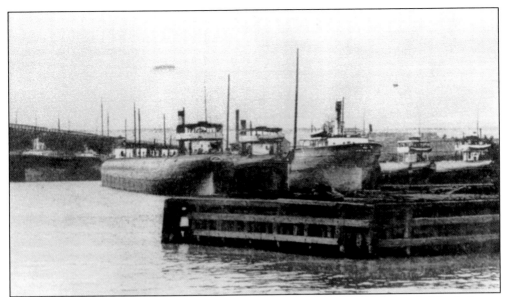

DOCKED WHALEBACK BARGES. This late-1890s photograph shows four whaleback barges docked at Duluth, Minnesota, along with a conventional steamer. The barges are waiting their turn under the chutes of the ore dock in the background. (Courtesy of the University of Detroit Mercy Special Collections, Fr. Edward J. Dowling, S. J. Marine Historical Collection.)

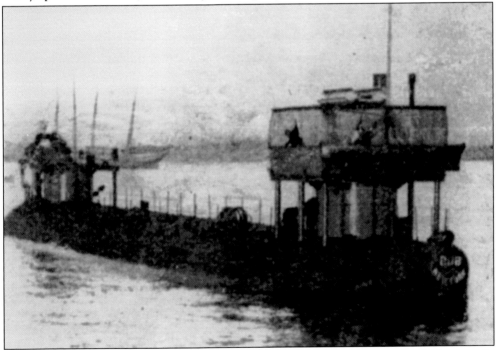

BARGE 202. *Barge 202* was launched from the Handren and Robins Atlantic Dock Company in Brooklyn, New York, on April 30, 1890, and sent to the Great Lakes. She was renamed *Fannie* in 1905 and returned to the Atlantic in 1908. She sank off New Jersey on January 24, 1908, with the loss of one of her crew. (Courtesy of the University of Detroit Mercy Special Collections, Fr. Edward J. Dowling, S. J. Marine Historical Collection.)

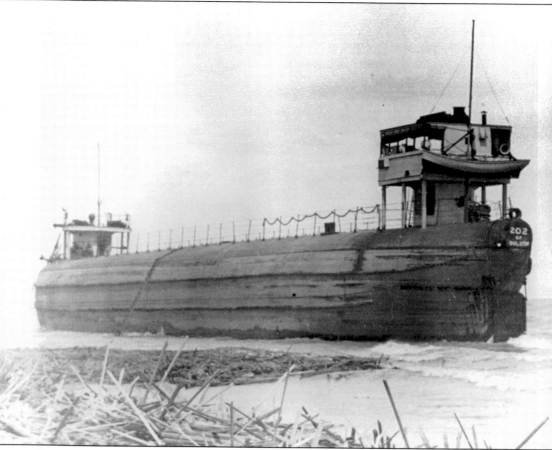

BARGE 202 AGROUND. On Saturday, September 7, 1901, *Barge 202*, while in the tow of the steamer *Wawatam*, was stranded on the sandy shores of Lake Huron, just north of the St. Clair River, during a northeastern gale. The problems of sailing in the gale were compounded by the smoke from numerous forest fires near the lake that created a haze (and very poor visibility) over the water. According to newspaper accounts of the day, *Barge 202* was driven aground so hard that she was less than 20 feet from dry land. *Barge 202* sat on the shore for more than a week—and evidently became somewhat of a tourist attraction while there—before being pulled off the beach and, after being surveyed for damage, returned to service. (Courtesy of the University of Detroit Mercy Special Collections, Fr. Edward J. Dowling, S. J. Marine Historical Collection.)

Three

THE WHALEBACK
STEAMERS

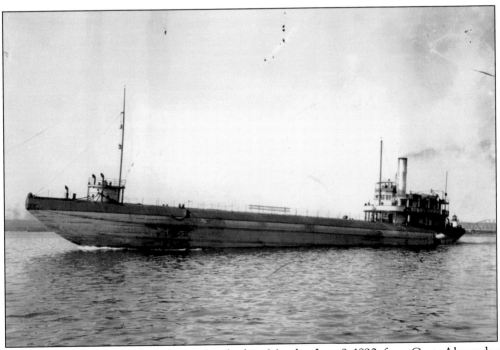

THE FIRST WHALEBACK STEAMER. Launched on Monday, June 9, 1890, from Capt. Alexander McDougall's first small shipyard at Rice's Point in the Duluth Harbor, the *Colgate Hoyt* was the first of 17 whaleback steamers McDougall would build over the next eight years. On December 26, 1909, less than 20 years after her launch, the *Colgate Hoyt* (sailing under the name *Thurmond*) sank off Seaside Park, New Jersey, during an Atlantic storm. All of the steamer's crewmen were rescued. (Courtesy of the Historic Photo Collection/Milwaukee Public Library.)

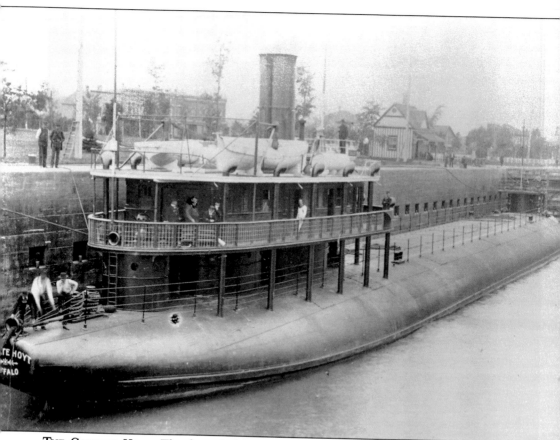

THE COLGATE HOYT. The first whaleback steamer built by McDougall and the ASBC, the *Colgate Hoyt* helped McDougall convince a skeptical Great Lakes shipping fraternity of the cost effectiveness of the whaleback design. The initial cost of building the steamer was $120,000, approximately one-third less than the cost of building a conventional Great Lakes steamer of the same size. The *Colgate Hoyt* was 276.5 feet long, 36 feet two inches of beam, and had an 18-foot-11-inch draft. Under sail, the *Colgate Hoyt* demonstrated that she could carry significantly more tonnage per displacement ton than conventional Great Lakes steamers. The cost of the general operation of the *Colgate Hoyt* showed a marked improvement as the boat steamed on approximately 40 percent less coal than other steamers of the day. Additionally, she could reach the blazing speed of 14 knots, making her one of the fastest boats sailing the Great Lakes. (Courtesy of the University of Detroit Mercy Special Collections, Fr. Edward J. Dowling, S. J. Marine Historical Collection.)

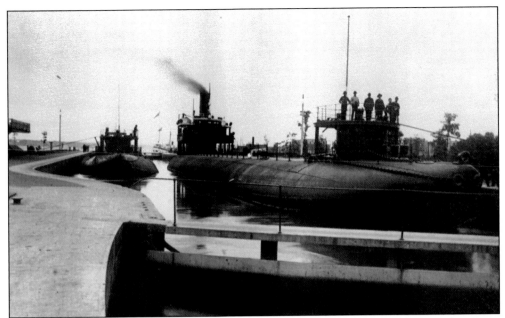

COLGATE HOYT AT THE SOO. In this photograph, taken around 1900, the steamer *Colgate Hoyt* (right) and an unidentified whaleback barge (left) are seen in one of the locks at the Soo. Both the boats are running with full loads in their cargo holds. Steamers towing barges were a very common method of running cargo across the lakes in the 19th and early 20th centuries. (Courtesy of the Great Lakes Historical Society.)

COLGATE HOYT LOADING COAL. This photograph, taken between the spring of 1900 and March 1905, shows the *Colgate Hoyt*, perhaps at Conneaut, Ohio, taking on a load of coal. The boat is in trim and the bow rides just a few inches higher than the stern to help maintain stability. (Courtesy of the University of Detroit Mercy Special Collections, Fr. Edward J. Dowling, S. J. Marine Historical Collection.)

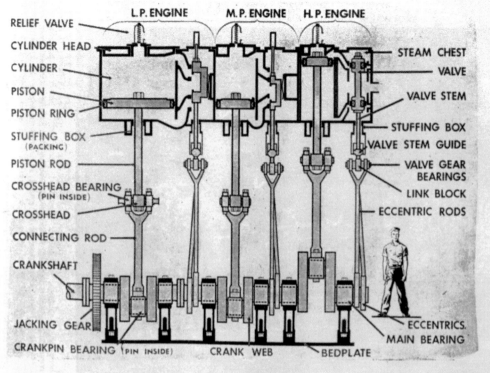

L. P. ENGINE **M. P. ENGINE** **H. P. ENGINE**

RELIEF VALVE

CYLINDER HEAD

CYLINDER

PISTON

PISTON RING

STUFFING BOX (PACKING)

PISTON ROD

CROSSHEAD BEARING (PIN INSIDE)

CROSSHEAD

CONNECTING ROD

CRANKSHAFT

JACKING GEAR

CRANKPIN BEARING (PIN INSIDE)

STEAM CHEST

VALVE

VALVE STEM

STUFFING BOX

VALVE STEM GUIDE

VALVE GEAR BEARINGS

LINK BLOCK

ECCENTRIC RODS

ECCENTRICS

MAIN BEARING

CRANK WEB

BEDPLATE

Fig. 134. Triple expansion engine.

THE TRIPLE EXPANSION ENGINE. This diagram provides an excellent view of the major components of the triple expansion engine, the steam-powered engine that drove 13 of the 17 whaleback steamers. The steam for the engine was developed in huge coal-fired boilers situated forward of the engine room and then piped to the engine. The engine was called a triple expansion because it used the same steam three times in three increasingly larger cylinders at increasingly lower pressures to turn the boat's crankshaft. The triple expansion engines were significantly more efficient and effective power plants than the fore and aft compound steam engines that drove the earliest whaleback steamers. The engines were huge, towering two-decks tall in the whaleback's engine rooms. The image of the crewman at the lower right shows the relative size of the engines. (Courtesy of Cornell Maritime Press.)

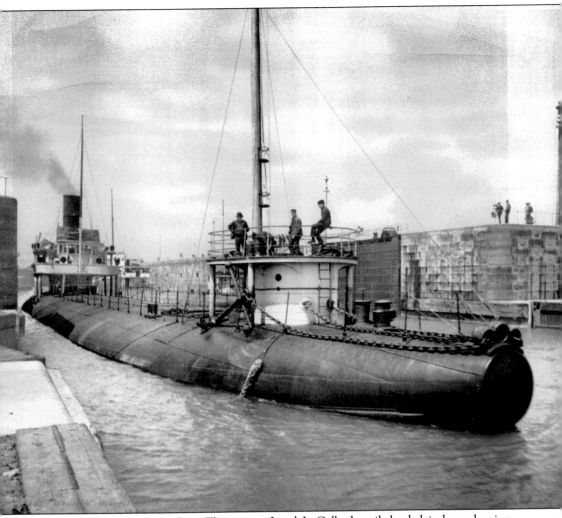

THE JOSEPH L. COLBY AT THE SOO. The steamer *Joseph L. Colby*, heavily loaded, is shown leaving the Poe Lock at Sault Ste. Marie, Michigan, about 1891. The *Joseph L. Colby*, the second steamer built by Capt. Alexander McDougall, was launched on Monday, November 15, 1890, from West Superior, Wisconsin. She was 265 feet long, 36 feet of beam, and had a 22-foot draft. The *Joseph L. Colby* had seven hatches on her deck that led to three separate cargo compartments in her hull. She was capable of carrying 2,000 tons of bulk cargo. The *Joseph L. Colby* had an 800 horsepower fore and aft compound engine built by the S. F. Hodge Company of Detroit, Michigan, and two Scotch boilers manufactured by the Lake Erie Boiler Works of Buffalo, New York. (Courtesy of the Judge Joseph H. Steere Room, Bayliss Public Library, Sault Sainte Marie, Michigan.)

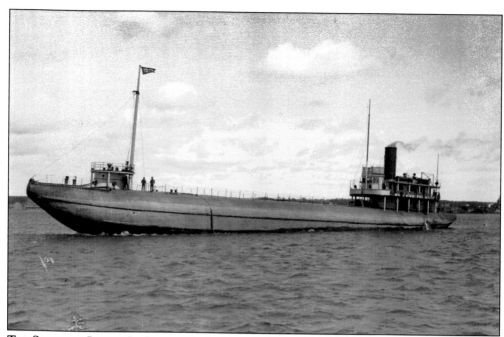

THE STEAMER JOSEPH L. COLBY. The *Joseph L. Colby*, with her fore and aft combination engine, was capable of speeds up to 17 miles per hour. Under the name *Bay State*, she was scrapped in Chicago in 1935, after having been owned by 10 different companies during her 45-year career. (Courtesy of the Historic Photo Collection/Milwaukee Public Library.)

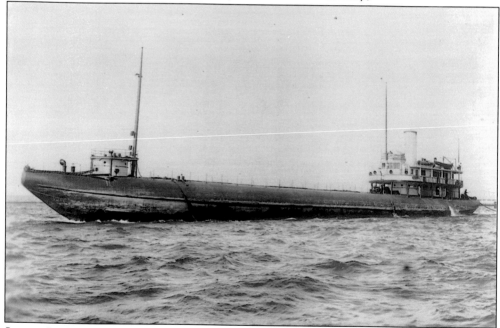

JOSEPH L. COLBY. The *Joseph L. Colby*, shown here in 1905, was the first whaleback steamer built in ASBC's new shipyard in West Superior, Wisconsin. Her first frames were laid on August 8, 1890, and just over three months later, on November 15, 1890, she slid down the ways into Howard's Pocket of the Duluth Harbor. (Author's collection.)

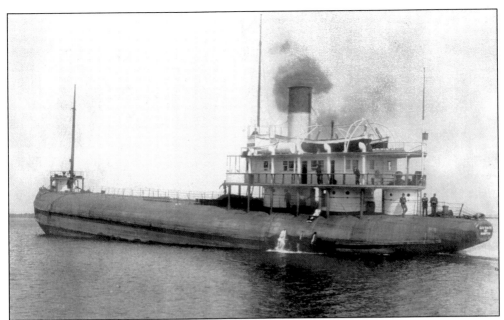

THE STEAMER BAY STATE. The steamer *Bay State*, running light (without cargo), presents a classic whaleback profile—a rounded hull, tapered ends with a single bow turret, and a stern superstructure atop three turrets. The *Bay State*, launched on November 15, 1890, as the *Joseph L. Colby* at West Superior, Wisconsin, was the second whaleback steamer built by Capt. Alexander McDougall and ASBC. (Courtesy of the Michigan Maritime Museum Collection.)

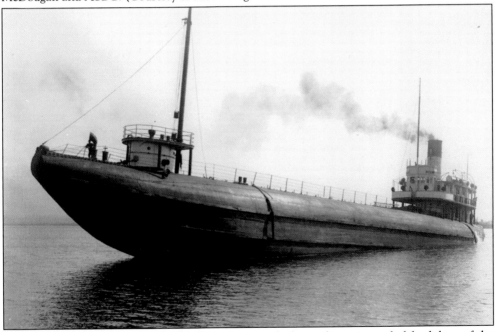

THE STEAMER BAY STATE IN 1905. This photograph shows the unique whaleback bow of the steamer *Bay State*. Because of their upturned bows, the whalebacks were excellent ice breakers and were used to clear channels through ice for other ships for many years on the Great Lakes. (Courtesy of the Historic Photo Collection/Milwaukee Public Library.)

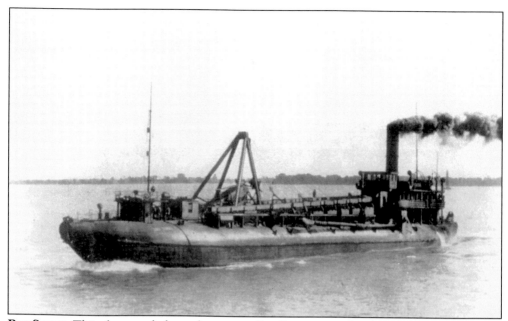

BAY STATE. This photograph shows the steamer *Bay State* as a sand sucker in the mid-1920s. She was converted to a self-unloading workboat in 1925 at the Leatham D. Smith Dock Company at Sturgeon Bay, Wisconsin. The *Bay State* ended her days being abandoned and finally scrapped in Chicago in 1935. (Courtesy of the Michigan Maritime Museum Collection.)

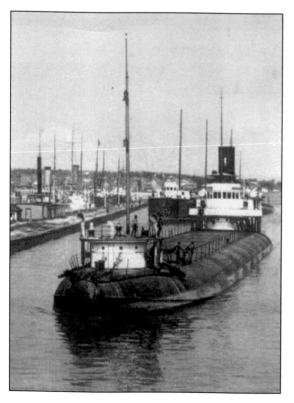

A WHALEBACK STEAMER AT THE SOO. In this early-1900s photograph, an unidentified whaleback steamer is shown running downbound, fully loaded, through the locks at the Soo. Situated on either side of the bow turret, two of the unique triangular anchors designed and patented by Capt. Alexander McDougall can be seen. The anchors became standard equipment on most whalebacks for a number of years. (Courtesy of the Michigan Maritime Museum Collection.)

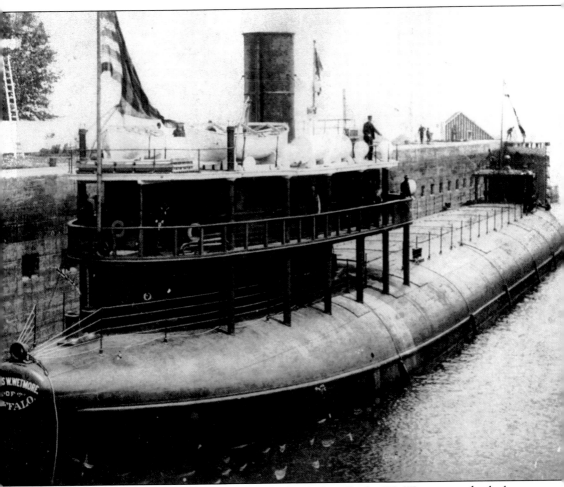

THE CHARLES W. WETMORE. This photograph shows the *Charles W. Wetmore* as she locks through the Soo Locks in June 1891. Although the *Charles W. Wetmore* had a very short sailing career it was a remarkably exciting career. She was built at West Superior, Wisconsin, and launched on Saturday, May 23, 1891. One month later, on June 23, 1891, she became the first steamer to shoot the very dangerous St. Lawrence Rapids with none other than McDougall on board to supervise the transit. The *Charles W. Wetmore* continued the adventure by sailing to England with a cargo hold of Midwest wheat. The *Charles W. Wetmore* returned to the United States, loaded a hold full of machinery at Wilmington, Delaware, and sailed around Cape Horn to Everett, Washington, a 15,000-mile voyage. The *Charles W. Wetmore* continued sailing the Pacific seaboard but on a stormy September 8, 1892, she was stranded on a sand spit at Coos Bay, Oregon. Despite the valiant efforts of the crew, the boat became a total loss. (Courtesy of the Historic Photo Collection/Milwaukee Public Library.)

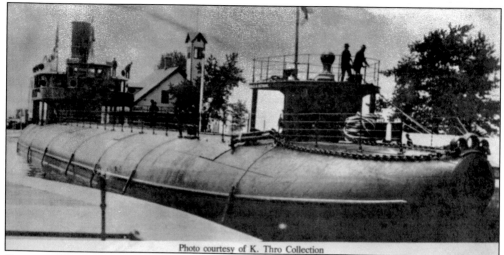

Photo courtesy of K. Thro Collection

CHARLES W. WETMORE AT THE SOO. This 1891 photograph shows the steamer *Charles W. Wetmore*, the third whaleback steamer built, leaving the Weitzel Lock downbound at the Soo. The *Charles W. Wetmore* was 265 feet long with a beam of 38 feet and a draft of 24 feet. She could carry 3,000 tons of bulk cargo. (Courtesy of the Judge Joseph H. Steere Room, Bayliss Public Library, Sault Sainte Marie, Michigan.)

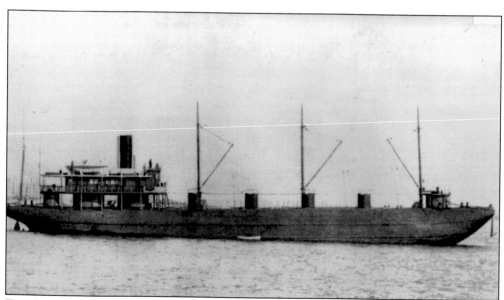

THE CHARLES W. WETMORE AT ANCHOR. This 1891 photograph shows the *Charles W. Wetmore* at anchor. The four small turrets on her deck between her larger bow and after turrets helped facilitate the loading of the boat and were retrofitted when the boat began sailing along the Pacific seaboard. (Courtesy of the University of Detroit Mercy Special Collections, Fr. Edward J. Dowling, S. J. Marine Historical Collection.)

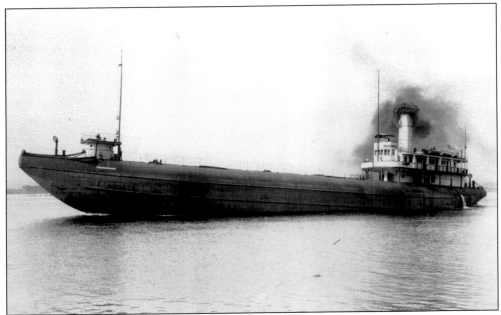

THE E. B. BARTLETT. The E. B. Bartlett was launched on July 9, 1891, from West Superior, Wisconsin, and was the identical sister ship of the A. D. Thomson. The E. B. Bartlett was 265 feet long, had a 38-foot beam, and a draft of 24 feet. She was powered by an 850-horsepower triple expansion engine built by the Northeastern Engine Works of Sunderland, England. (Courtesy of the Historic Photo Collection/Milwaukee Public Library.)

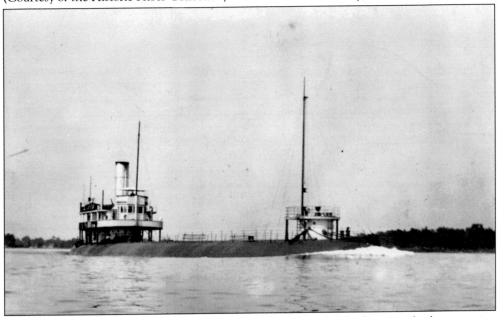

THE STEAMER E. B. BARTLETT. The E. B. Bartlett, the fifth whaleback steamer built, is running heavily loaded on one of the connecting waterways of the Great Lakes. This photograph, taken between summer 1901 and spring 1905, shows the E. B. Bartlett in her Pittsburgh Steamship Company colors. (Courtesy of the University of Detroit Mercy Special Collections, Fr. Edward J. Dowling, S. J. Marine Historical Collection.)

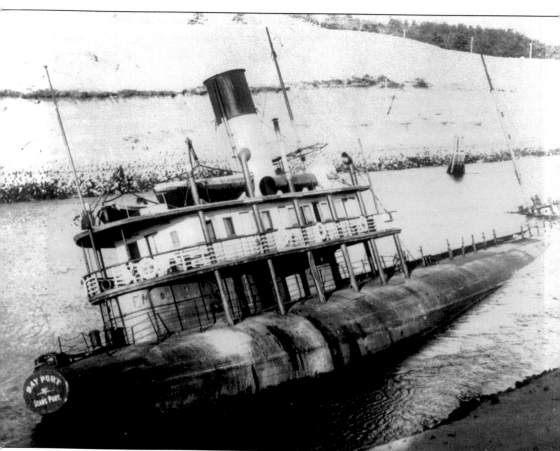

THE SINKING OF THE BAY PORT. A bit after noon on Wednesday, December 13, 1916, the *Bay Port*, loaded with 2,393 tons of coal, began her journey eastbound through the Cape Cod Canal under tow of a canal tug. Approximately halfway through her transit down the canal the *Bay Port* sheered into the south bank of the canal and grounded on a shoal. The *Bay Port* was held against the bank of the canal by several tugs until the next high tide. The next morning a hole was discovered in the *Bay Port*'s hull, which was repaired by the crew. The *Bay Port* slid off the shore and her trip through the canal continued under tow for about a mile when she again sheered, this time into the canal's north shore. The bow of the *Bay Port* then pulled away from the bank, swung downstream and settled with the aft end still high on the north bank. The boat was a total loss after her second grounding. (Courtesy of the United States Army Corps of Engineers, Cape Cod Canal Field Office.)

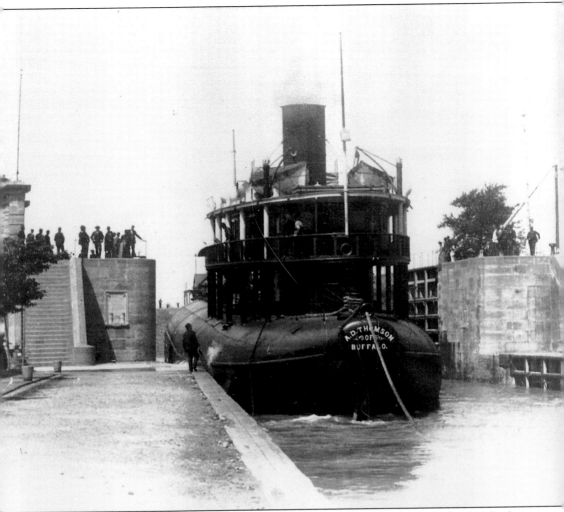

THE A. D. THOMSON AT THE SOO. In this photograph the A. D. Thomson, the forth whaleback steamer built by Capt. Alexander McDougall, is shown passing upbound through the Soo Locks sometime between 1891 and 1905. She was launched on Saturday, June 6, 1891, at Duluth, Minnesota. The A. D. Thomson was 265 feet long with a beam of 38 feet and a draft of 24 feet. She had a capacity of 3,000 tons of bulk cargo. The A. D. Thomson was the first whaleback to operate with a triple expansion engine (manufactured by the S. F. Hodge Company of Detroit with a rating of 1,000 horsepower) that used the same steam three times for a significant increase in efficiency. In her later years the Bay View (as she was known after March 28, 1905) was refitted and worked as a sand sucker in many of the harbors around the Great Lakes. (Author's collection.)

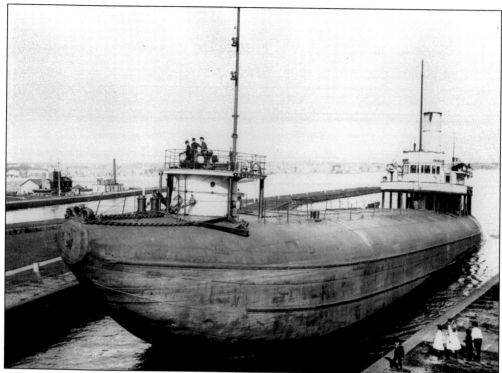

A. D. Thomson Light at the Soo. The steamer *A. D. Thomson* is running upbound and light through the Soo Locks during the 1890s. This photograph shows the unique bow design of the whalebacks. It also shows a McDougall anchor on the steamer's deck, just to the right of the bow turret. (Courtesy of the University of Detroit Mercy Special Collections, Fr. Edward J. Dowling, S. J. Marine Historical Collection.)

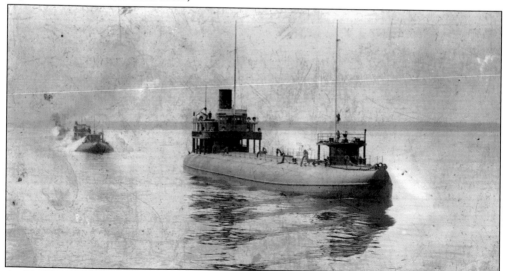

A. D. Thomson and Two Barges. In this 1890s photograph, the *A. D. Thomson* (center) is shown towing two whaleback barges (left) on calm Great Lakes waters. All three of the whalebacks are fully loaded. (Courtesy of the University of Detroit Mercy Special Collections, Fr. Edward J. Dowling, S. J. Marine Historical Collection.)

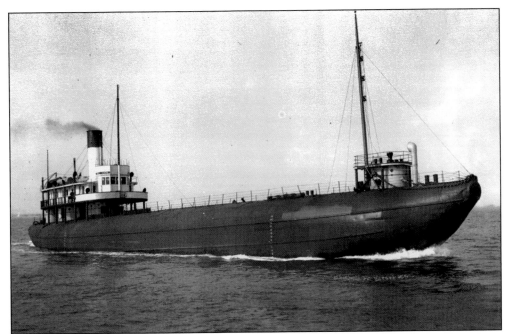

THE *BAY VIEW* UNDER STEAM. The *A. D. Thomson* was renamed the *Bay View* on March 28, 1905, upon her sale to the Boutell Steel Barge Company of Bay City, Michigan. She retained the *Bay View* name for the rest of her 31 years on the Great Lakes. (Courtesy of the University of Detroit Mercy Special Collections, Fr. Edward J. Dowling, S. J. Marine Historical Collection.)

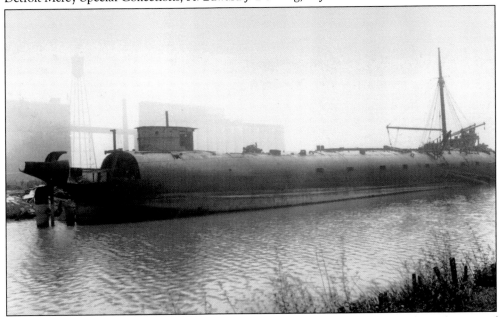

THE *BAY VIEW* SCRAPPED AT CHICAGO. This photograph illustrates the fate of many of Capt. Alexander McDougall's whalebacks. The *Bay View* (launched as the *A. D. Thomson* on June 6, 1891, at West Superior, Wisconsin) is being cut apart and scrapped at a slip off 101st Street in South Chicago in the early summer of 1936 after 45 years of sailing. (Courtesy of the Historic Photo Collection/Milwaukee Public Library.)

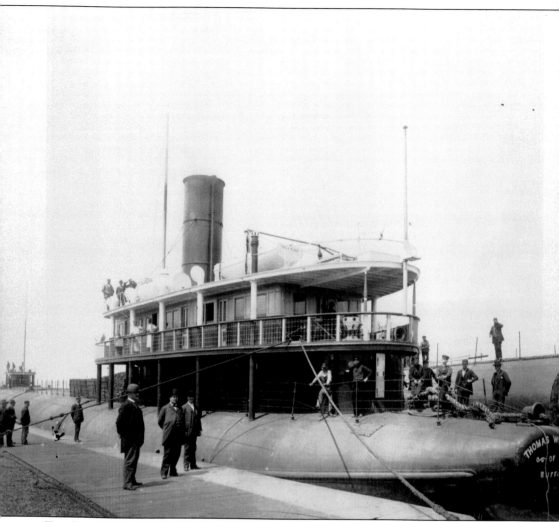

THE STEAMER *THOMAS WILSON*. The *Thomas Wilson* sailed for a brief 10 years before being sunk by the wooden steamer *George G. Hadley* just outside the Duluth, Minnesota, harbor on June 7, 1902. At 10:27 a.m. that day the *Thomas Wilson*, downbound with 2,700 tons of iron ore, was passing the *George G. Hadley*, upbound with a full cargo of coal, port to port approximately a mile and a half southeast of Duluth's Minnesota Point. The *George G. Hadley* turned, in what appeared to be a failure to observe proper passing rules, to port and rammed the *Thomas Wilson*'s port side at her number 12 hatch, cutting deeply into the steamer. The *Thomas Wilson* immediately began to take on water and within three minutes sank bow first in 70 feet of water taking 9 of her 20 crewmen down with her. The *George G. Hadley* picked up a number of the *Thomas Wilson*'s survivors and headed for Duluth but settled in 20 feet of water several hundred yards off the Minnesota Point beach. (Courtesy of the Historic Photo Collection/Milwaukee Public Library.)

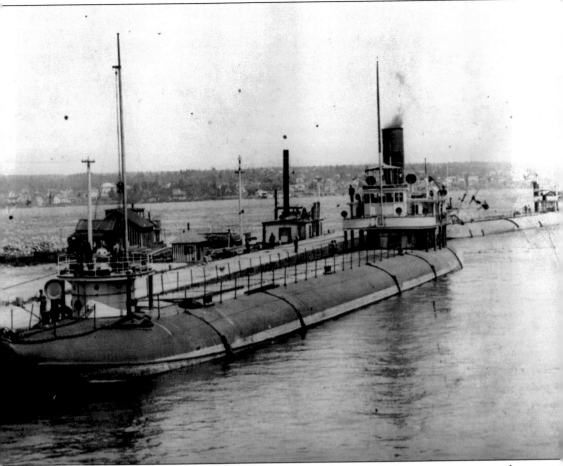

THE THOMAS WILSON. The *Thomas Wilson* was the sixth whaleback steamer constructed by Capt. Alexander McDougall. She was launched on Saturday, April 30, 1892, from West Superior, Wisconsin, with a length of 308 feet, a beam of 38 feet, and a draft of 24 feet. The *Thomas Wilson* had two Scotch boilers built by the Lake Erie Boiler Works of Buffalo, New York, and a triple expansion engine, manufactured by the Frontier Iron Works of Detroit, capable of producing 900 horsepower. The *Thomas Wilson* had 12 hatches on her deck leading to a single cargo hold, and she was capable of carrying 3,300 tons of bulk cargo. The *Thomas Wilson* was named after Capt. Thomas Wilson, one of McDougall's closest friends and a Great Lakes sailing legend in his own right. This 1890s photograph shows the *Thomas Wilson* upbound at the Soo Locks with the whaleback barge she is towing moving in behind her to await the opening of the lock. (Courtesy of the University of Detroit Mercy Special Collections, Fr. Edward J. Dowling, S. J. Marine Historical Collection.)

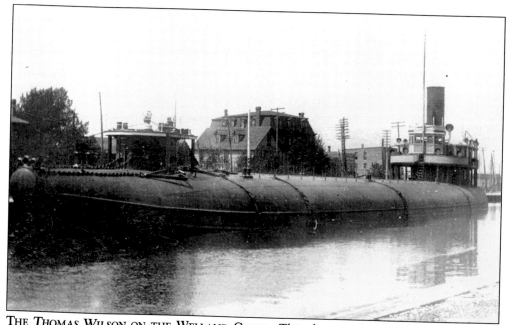

THE *THOMAS WILSON* ON THE *WELLAND CANAL*. This photograph, taken in either 1900 or 1901, shows the *Thomas Wilson* moving slowly along the Welland Canal. The *Thomas Wilson* was the identical sister of the *James B. Colgate*, the *Samuel Mather*, and the *John B. Trevor*. (Courtesy of the University of Detroit Mercy Special Collections, Fr. Edward J. Dowling, S. J. Marine Historical Collection.)

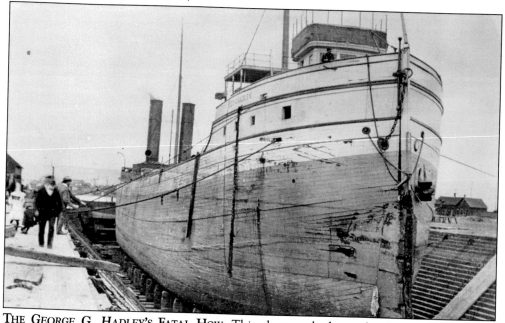

THE *GEORGE G. HADLEY'S* FATAL HOW. This photograph shows the damaged bow of the steamer *George G. Hadley* after she rammed and sank the whaleback steamer *Thomas Wilson* just outside the Duluth Harbor on June 7, 1902. The bow cut deeply into the left side of the *Thomas Wilson* at her number 12 hatch. (Courtesy of the University of Detroit Mercy Special Collections, Fr. Edward J. Dowling, S. J. Marine Historical Collection.)

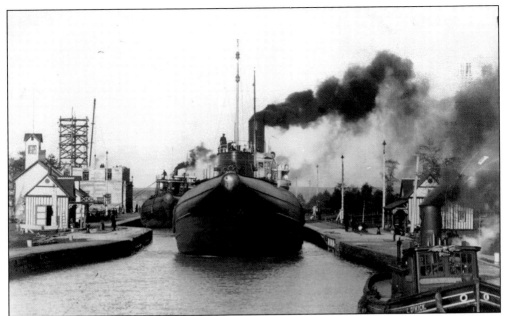

TWO WHALEBACKS AT THE SOO. A whaleback steamer (foreground) and a whaleback barge (rear) are shown in the Weitzel Lock at the Soo about 1895. The steamer is underway and heading out of the lock while the barge is still tied up to the side of the lock but getting ready for her tow out of the lock. (Courtesy of the Judge Joseph H. Steere Room, Bayliss Public Library, Sault Sainte Marie, Michigan.)

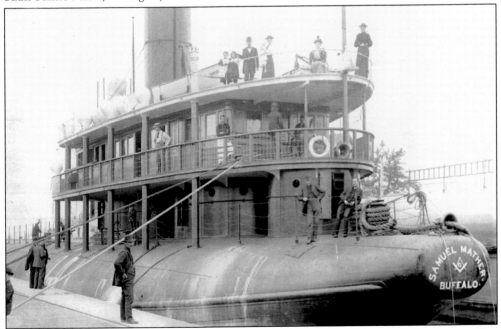

THE STEAMER *SAMUEL MATHER*. The steamer *Samuel Mather* (launched May 21, 1892, at West Superior, Wisconsin) is shown transiting the Soo Locks sometime between her launch and March 1900. Oddly the *Samuel Mather* sports a Masonic symbol on her stern. (Courtesy of the University of Detroit Mercy Special Collections, Fr. Edward J. Dowling, S. J. Marine Historical Collection.)

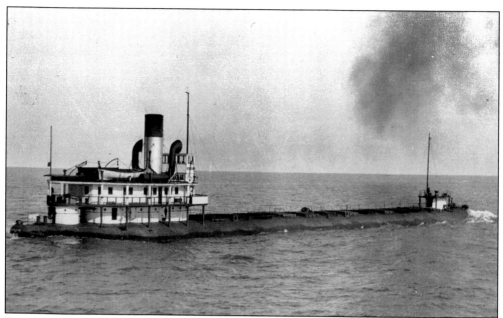

THE SAMUEL MATHER UNDER WAY. The *Samuel Mather,* fully loaded and low in the water, steams on one of the Great Lakes in the early 1900s. The *Samuel Mather* was 308 feet long, 38 feet abeam, and had a draft of 24 feet. She could carry 3,500 tons of bulk cargo in her hold. (Courtesy of the University of Detroit Mercy Special Collections, Fr. Edward J. Dowling, S. J. Marine Historical Collection.)

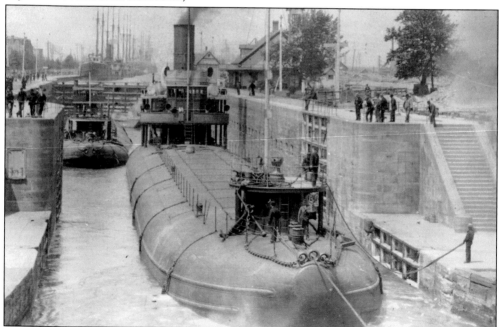

THE SAMUEL MATHER AT THE SOO. In this photograph, taken in the early 1890s, the steamer *Samuel Mather* is beginning to steam out of one of the Soo Locks with a heavily loaded whaleback barge in tow. (Courtesy of the University of Detroit Mercy Special Collections, Fr. Edward J. Dowling, S. J. Marine Historical Collection.)

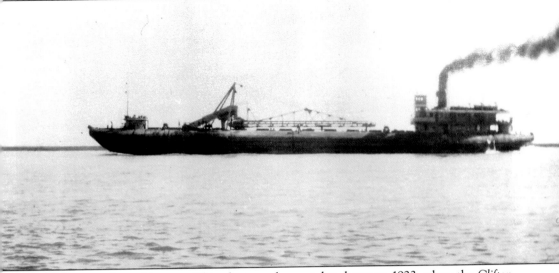

THE CLIFTON—STILL MISSING. This photograph was taken between 1923, when the *Clifton* (launched as the *Samuel Mather*) was converted to a self-unloader, and September 21 or 22, 1924, when she sank in Lake Huron taking all 27 crewmen down with her. As with so many Great Lakes boats over the years, the *Clifton* simply disappeared during a vicious storm off the eastern coast of Michigan somewhere between Oscoda and Thunder Bay. She sailed from Sturgeon Bay, Wisconsin, with 2,200 tons of crushed stone on September 20, 1924, en route to Detroit. The *Clifton* vanished and the search for her has lasted, with no success, for more than 80 years. In the months following the wreck, the bodies of many of the *Clifton*'s crew were found scattered all over Lake Huron, from the south shore of Ontario's Bruce Peninsula, to the waters just off Michigan's Thunder Bay, to an area in the middle of Lake Huron. (Courtesy of the University of Detroit Mercy Special Collections, Fr. Edward J. Dowling, S. J. Marine Historical Collection.)

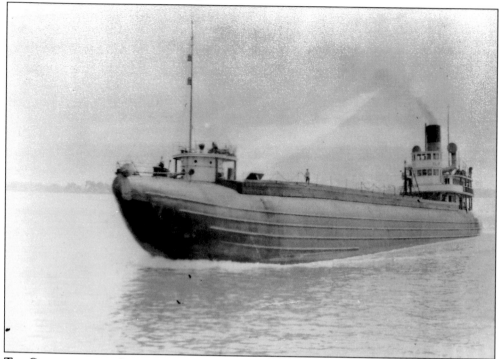

THE CLIFTON ON THE GREAT LAKES. The steamer *Clifton* is shown in this 1923–1924 photograph steaming light on one of the Great Lakes. The *Clifton* would be lost on Lake Huron no more than a year and a half later with all hands lost. (Courtesy of the University of Detroit Mercy Special Collections, Fr. Edward J. Dowling, S. J. Marine Historical Collection.)

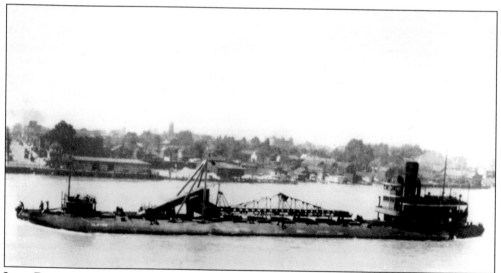

LAST PHOTOGRAPH OF THE CLIFTON? This 1924 image of the *Clifton*, showing the massive and newly installed self-unloading equipment on her deck, could well be one of the last photographs taken of the steamer. There was speculation that the unloading equipment broke free during a storm and capsized the boat on Lake Huron. (Courtesy of the University of Detroit Mercy Special Collections, Fr. Edward J. Dowling, S. J. Marine Historical Collection.)

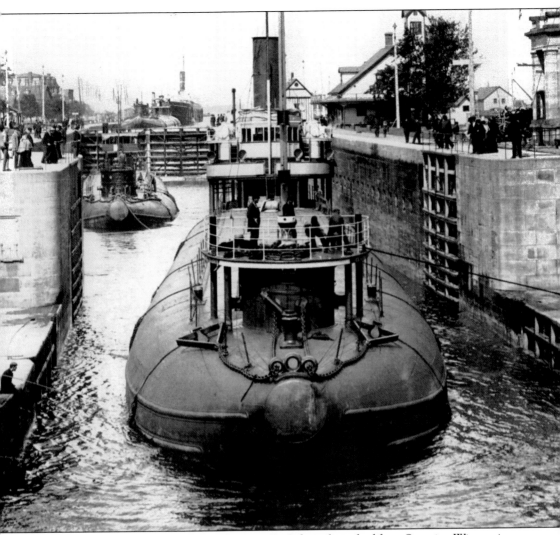

THE JAMES B. COLGATE AT THE SOO. The *James B. Colgate*, launched from Superior, Wisconsin, on September 21, 1892, is shown going through the Soo Locks in 1893. The *James B. Colgate* met her fate less than 25 years later when, carrying 3,300 tons of coal from Buffalo, New York, to Fort William, Ontario, she sank taking 26 of her 27 crewmen to the bottom with her during the "Black Friday" storm on Lake Erie on October 20, 1916. Only the boat's captain, Walter Grashaw, survived. Grashaw reported that the *James B. Colgate* began taking on water during the storm, took on a list when the boat's pumps could not keep up with the volume of incoming water, began to settle by the bow and, at approximately 10:00 p.m., struck bottom in a plunge off a huge wave. Grashaw was adrift for two days before being rescued by the *Marquette and Bessimer No. 2*. The *James B. Colgate* sank approximately 18 miles southwest of Long Point, Ontario, in 85 feet of water. (Courtesy of the Great Lakes Historical Society.)

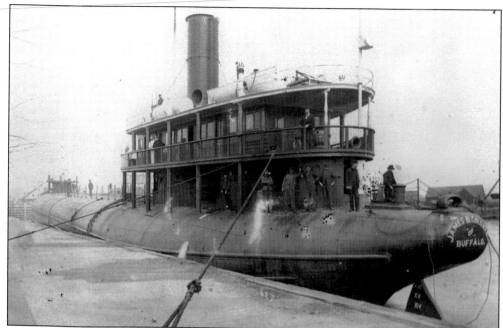

JAMES B. COLGATE DOCKED. The *James B. Colgate* was fitted with a 1,000 horsepower Marinette Iron Works triple expansion engine and two Milwaukee Boiler Works Scotch boilers rated at 160 pounds pressure per square inch. She had 12 hatches, nine feet by 16 feet, on 24-foot centers and a single cargo compartment. (Courtesy of the University of Detroit Mercy Special Collections, Fr. Edward J. Dowling, S. J. Marine Historical Collection.)

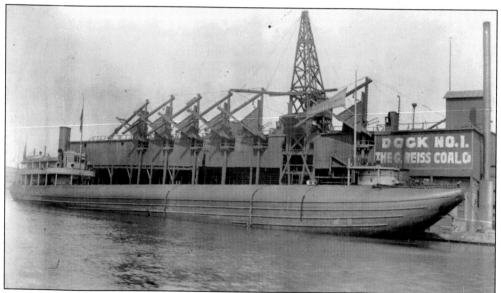

THE JAMES B. COLGATE. The *James B. Colgate* is loading coal through her 12 hatches into her single cargo hold at the Reiss Coal Company Dock No. 1 at Sheboygan, Wisconsin, sometime between 1898 and 1900. The *James B. Colgate* was 308 feet long, had a beam of 38 feet, a draft of 24 feet, and could carry 3,300 tons of cargo. (Courtesy of the Historic Photo Collection/Milwaukee Public Library.)

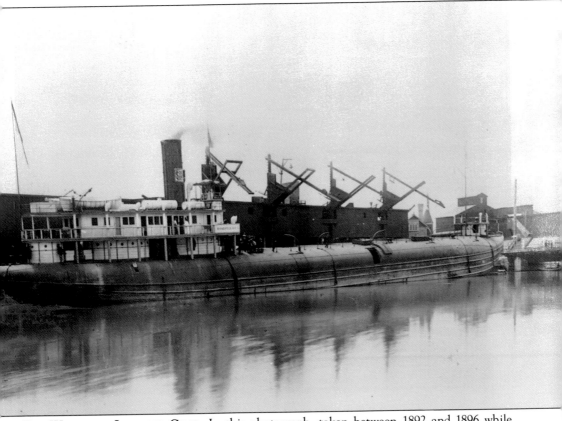

THE WASHBURN LOADING COAL. In this photograph, taken between 1892 and 1896 while the *Washburn* was owned by the Minneapolis, St. Paul and Buffalo Steamship Company (also known as the Soo Railroad Line), the steamship is being readied to receive a load of coal. The *Washburn* was built specifically for the Soo Line and was launched on Saturday, June 25, 1892, at West Superior, Wisconsin. She was 320 feet long with abeam of 42 feet and a draft of 25 feet. The *Washburn* had a single cargo compartment that held 3,500 tons of cargo. The steamer was renamed the *James B. Neilson* in June 1896 and continued to sail the Great Lakes for the Bessemer Steamship Company and the Pittsburgh Steamship Company. In March 1928, she was renamed the *J. T. Reid* and was converted to an automobile carrier. In 1936, the *J. T. Reid* was abandoned at Cleveland, and later that year she was scrapped. (Courtesy of the University of Detroit Mercy Special Collections, Fr. Edward J. Dowling, S. J. Marine Historical Collection.)

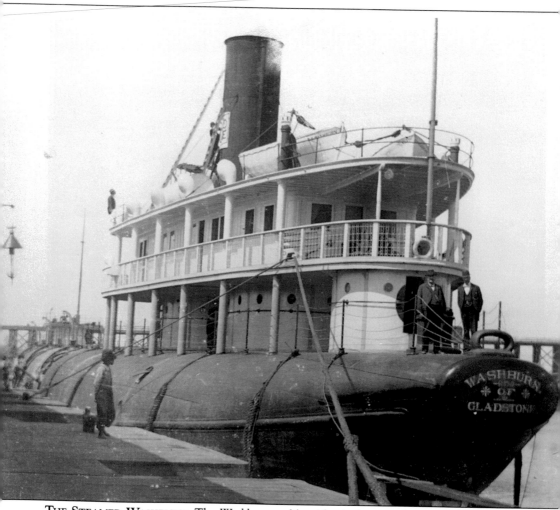

THE STEAMER WASHBURN. The *Washburn* and her identical sister, the steamer *Pillsbury*, were launched on Saturday, June 25, 1892—along with the tug *Islay*—from the ASBC shipyard at West Superior. The first-ever "head of the lakes" triple launching was witnessed by a reported 20,000 folks from the Duluth-West Superior area. So many people watched the activities that space at the shipyard was at a significant premium and rooftops became grandstands and Howard's Pocket (the small bay on which the ASBC was built) was clogged with all manner of small ferryboats, tugs, and yachts. The launching was attended by officers of the Minneapolis, St. Paul and Buffalo Steamship Company for whom the steamers had been built and Capt. Alexander McDougall officiated at the festivities. The *Washburn* was launched into slip No. 2 while the *Pillsbury* was launched into slip No. 3. (Courtesy of the University of Detroit Mercy Special Collections, Fr. Edward J. Dowling, S. J. Marine Historical Collection.)

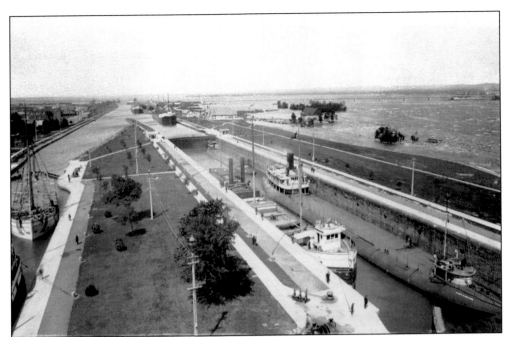

THE JAMES B. NEILSON AT THE SOO. This photograph, taken from atop of the Soo Locks Administration Building sometime between June 1896 and mid-1904, shows the steamer *James B. Neilson* on the extreme right (launched as the *Washburn* on June 25, 1892, at West Superior, Wisconsin) and a whaleback barge, both fully loaded, in the Weitzel Lock at the Soo. (Courtesy of the Historic Photo Collection/Milwaukee Public Library.)

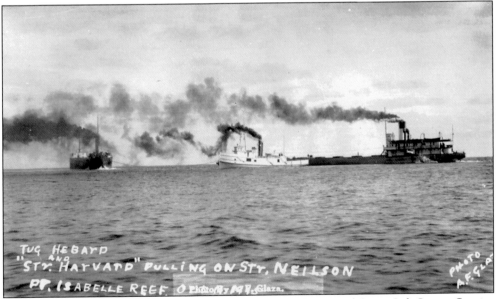

ON THE POINT ISABELLE REEF. This photograph, taken by United States Life Saving Service surfman Anthony F. Glaza of the Eagle Harbor United States Life Saving Service station, shows the steamer *James B. Neilson* being pulled off on the rocks at Pt. Isabelle Reef (off the Keweenaw Peninsula) by the steamer *Harvard* and the tug *Hebard*. (Courtesy of the University of Detroit Mercy Special Collections, Fr. Edward J. Dowling, S. J. Marine Historical Collection.)

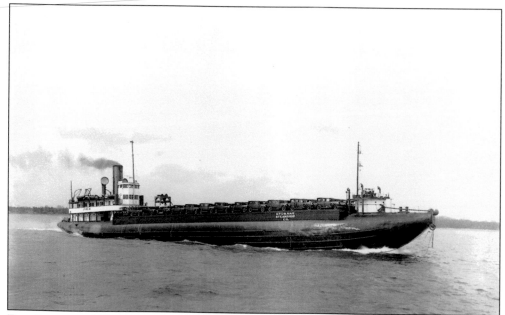

THE STEAMER J. T. REID. The *J. T. Reid* (launched as the *Washburn* on June 25, 1892) sailed as a car carrier after March 1928. In this photograph, the *J. T. Reid* is shown sailing one of the connecting waterways of the Great Lakes with a full load of new automobiles on her deck. In addition to the cars on her deck, automobiles were also carried in the steamer's hold. (Author's collection.)

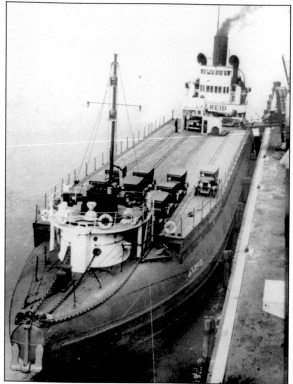

THE AUTOMOBILE CARRIER J. T. REID. This March 18, 1930, photograph of the *J. T. Reid* shows her loading cars on her specially designed flat wooden deck that fit over her original curved metal deck. The *J. T. Reid* was converted into an automobile carrier at the Reid Dry Dock Company in Port Huron, Michigan, in 1928 while owned by the Spokane Steamship Corporation. (Courtesy of the Great Lakes Historical Society.)

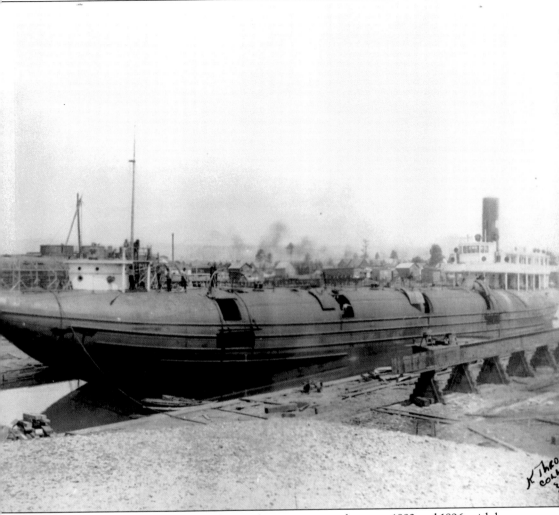

THE S.S. PILLSBURY. The steamer *Pillsbury* is shown, sometime between 1892 and 1896, with her four unique port side hatches open. The hatches were used to facilitate loading and unloading of package cargo in a between-deck arrangement called for by the specifications set forth in the contract the Soo Railroad gave to ASBC for the construction of the *Pillsbury* and her sister ship the *Washburn*. The *Pillsbury* and the *Washburn* were the only whaleback cargo steamers built with the side hatches. The *Pillsbury* failed to meet the contractual requirements specified for carrying cargo and was returned to Capt. Alexander McDougall in 1896. The *Pillsbury* was renamed the *Henry Cort* in June 1896 and then began perhaps the most ill-fated sailing career of any boat ever to set a hull on the Great Lakes. The *Henry Cort's* record of problems is legendary and includes at least three collisions, a serious grounding, three separate sinkings, and having a hand in the deaths of at least four people. (Courtesy of the Historic Photo Collection/Milwaukee Public Library.)

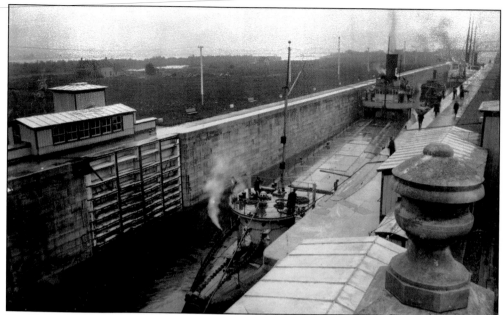

THE HENRY CORT AT THE CANADIAN SOO. The steamer *Henry Cort* shares the Canadian Soo Lock with several other boats in this 1900 photograph. The capstan and several stanchions, along with other equipment, situated on the top of the bow turret can be clearly seen. The wooden decking atop the bow turret can also be seen. (Courtesy of the Judge Joseph H. Steere Room, Bayliss Public Library, Sault Sainte Marie, Michigan.)

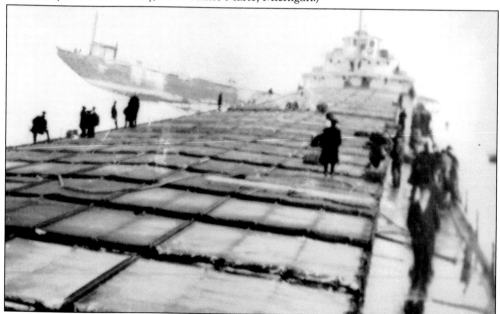

THE HENRY CORT'S FIRST SINKING. This photograph, taken on December 17, 1917, from the deck of the steamer *Midvale*, shows the *Henry Cort* sinking after being rammed by the *Midvale* near Colchester Light in Lake Erie. Thankfully there were no injuries or fatalities as a result of the accident. (Courtesy of the University of Detroit Mercy Special Collections, Fr. Edward J. Dowling, S. J. Marine Historical Collection.)

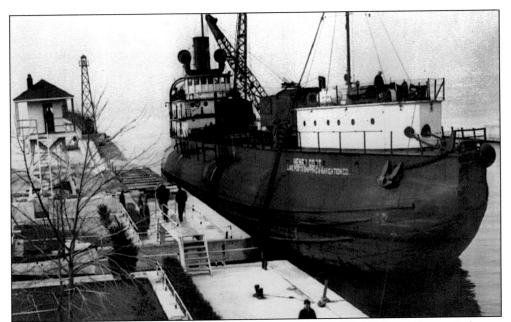

THE HENRY CORT AT SOUTH HAVEN. The whaleback steamer *Henry Cort* is shown tied up at the United State Coast Guard Station South Haven (Michigan) dock. This photograph, taken between June 1927 and November 1934, shows the *Henry Cort* with her last deck alteration consisting of the square sided flat deck, two deck cranes, and the enlarged bow turret. (Courtesy of the Michigan Maritime Museum Collection.)

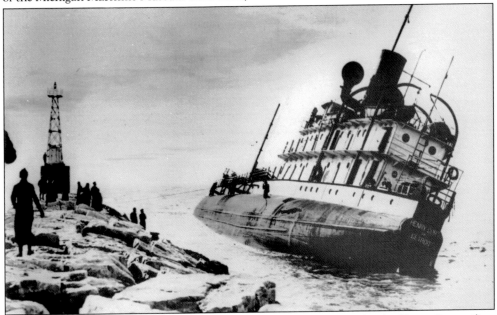

THE HENRY CORT'S LAST SINKING. At 9:45 p.m. on November 30, 1934, the *Henry Cort*, sailing in a severe storm on Lake Michigan with 600 tons of scrap iron in her hold, wrecked against the north breakwater of the Muskegon, Michigan, harbor. Her crew of 25 was rescued by the United States Coast Guard with the unfortunate loss of one Coast Guard rescuer. (Courtesy of the Historic Photo Collection/Milwaukee Public Library.)

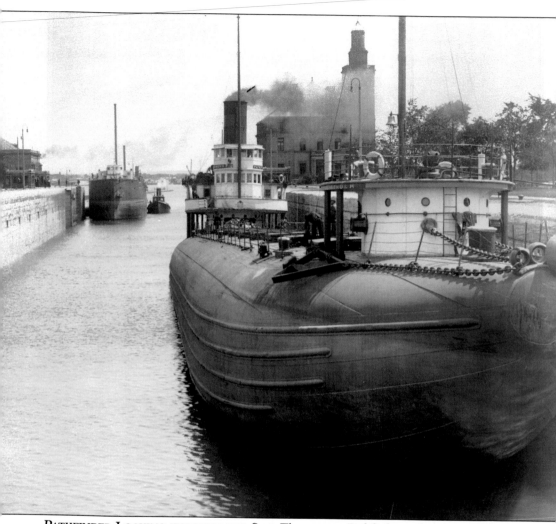

PATHFINDER LOCKING THROUGH THE SOO. The steamer *Pathfinder* is shown locking through the Soo Locks, upbound and without cargo. The *Pathfinder* was the 10th whaleback steamer built and was launched from West Superior, Wisconsin, on Saturday, July 16, 1892. She was 340 feet long, 42 feet wide, and had a draft of 25 feet. When she was built, the *Pathfinder* was powered by a Frontier Iron Works triple expansion engine capable of developing 1,600 horsepower. A slightly larger triple expansion engine replaced her original engine in 1920. Her initial three Scotch boilers were built by the Lake Erie Boiler Works of Buffalo, New York. They were replaced in 1908 with two somewhat larger, higher pressure boilers built by the American Shipbuilding Company of Cleveland. The *Pathfinder* was renamed *Progress* on February 11, 1921, and sailed under that name until she was scrapped at Cleveland during the winter of 1933–1934. (Courtesy of the Historic Photo Collection/Milwaukee Public Library.)

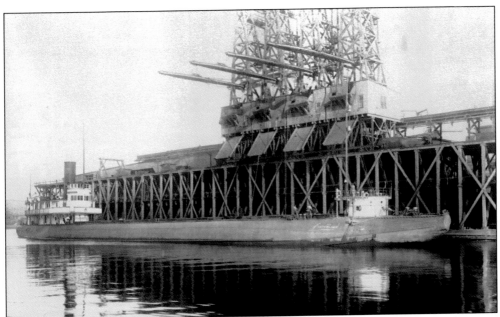

THE STEAMER PATHFINDER AT SHEBOYGAN. In this photograph, the *Pathfinder* is shown tied up to the coal docks at Sheboygan, Wisconsin, sometime between April 1913 and October 1920. The *Pathfinder*, capable of carrying 4,100 tons of bulk cargo in her single hold, had nine hatches on 24-foot centers on her main deck. (Courtesy of the Historic Photo Collection/Milwaukee Public Library.)

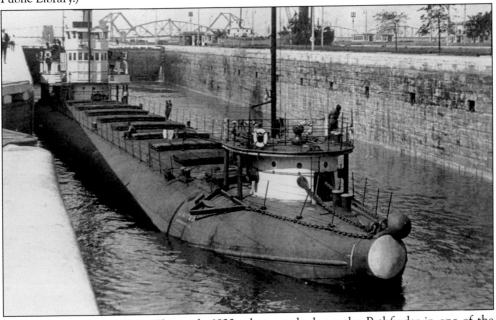

PATHFINDER AT THE SOO. This early 1920s photograph shows the Pathfinder in one of the locks at Sault Ste. Marie, Michigan, while sailing under the United Steamship Company colors. The McDougall anchor used by many of the whalebacks can be seen on the deck to the left of the bow turret. (Courtesy of the University of Detroit Mercy Special Collections, Fr. Edward J. Dowling, S. J. Marine Historical Collection.)

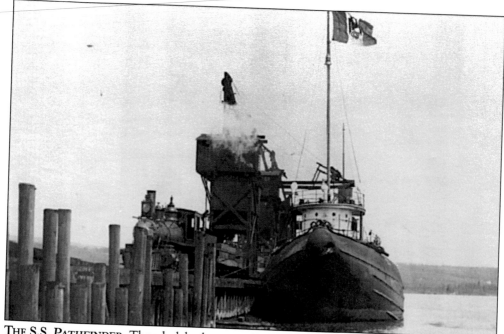

THE S.S. PATHFINDER. The whaleback steamer *Pathfinder* is shown loading a cargo of coal from the train sitting on a Great Lakes dock. The photograph, taken in the early 1900s, shows the *Pathfinder* listing to starboard as her cargo had not yet been trimmed. (Courtesy of the Michigan Maritime Museum Collection.)

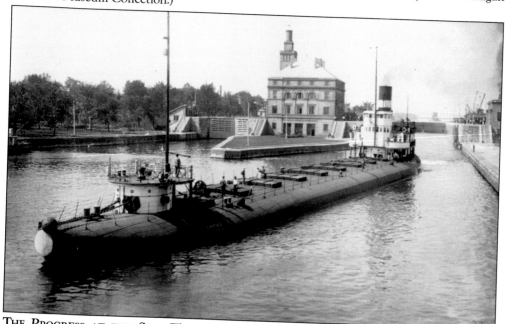

THE PROGRESS AT THE SOO. This photograph shows the steamer *Progress*, heavily loaded, downbound through the Soo Locks between 1921 and 1933. The *Progress* (launched as the *Pathfinder*) never tasted saltwater as she sailed the Great Lakes exclusively from her July 16, 1892, launch to her scrapping at Cleveland in the winter of 1933–1934. (Courtesy of the Great Lakes Historical Society.)

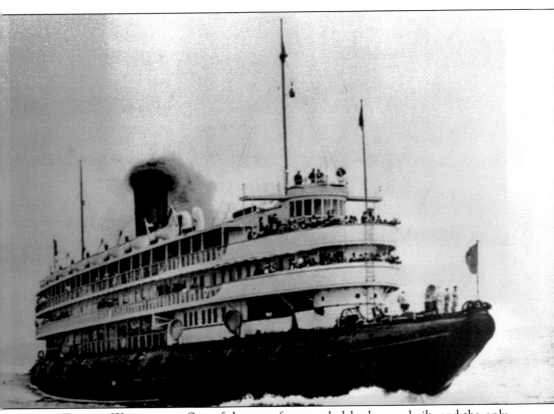

A Very Famous Whaleback. One of the most famous whalebacks ever built, and the only whaleback ever constructed to carry only passengers, the *Christopher Columbus* was launched at West Superior, Wisconsin, on December 3, 1892. The *Christopher Columbus* was specifically designed and contracted to carry passengers for the 1894 world's fair in Chicago. She carried 2 million-plus fairgoers between the Van Buren Street Dock and Jackson Park during the two years of the exposition. The *Christopher Columbus* could carry more than 4,000 passengers comfortably and could embark/disembark them all in under 10 minutes. The interior salons and cabins of the *Christopher Columbus* were finished to provide her passengers the height of ornate 19th-century Victorian splendor. At the conclusion of the world's fair, the *Christopher Columbus* began her second career running passengers between Chicago and Milwaukee—a job she held for almost 40 years. (Courtesy of the Michigan Maritime Museum Collection.)

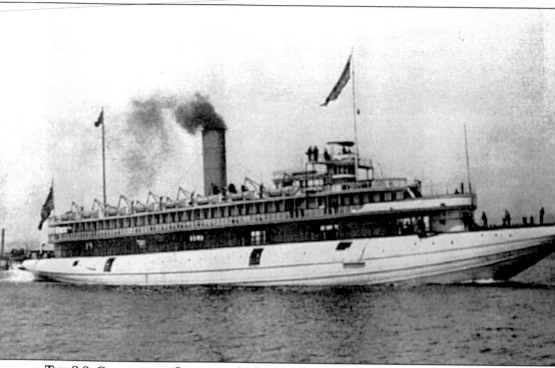

THE S.S. CHRISTOPHER COLUMBUS. In this photograph the famous passenger liner *Christopher Columbus* of the Columbian Whaleback Steamship Company is shown steaming near shore sometime between 1894 and 1899. Construction of the *Christopher Columbus* began on September 13, 1892, at the American Steel Barge Company in West Superior, Wisconsin. She was launched on Sunday, December 3, 1893, and was fully outfitted and ready for service by May 1893. The *Christopher Columbus* was 362 feet long with a 42-foot beam and a 24-foot draft. She was powered by an S. F. Hodge and Company triple expansion engine capable of producing more than 3,000 horsepower to speed the boat at 20 miles per hour. Her six Scotch boilers were built by the Cleveland Shipbuilding Company. The *Christopher Columbus* was built with nine watertight compartments and 10 independent steam pumps to control any problems with flooding of the hull. (Courtesy of the Michigan Maritime Museum Collection.)

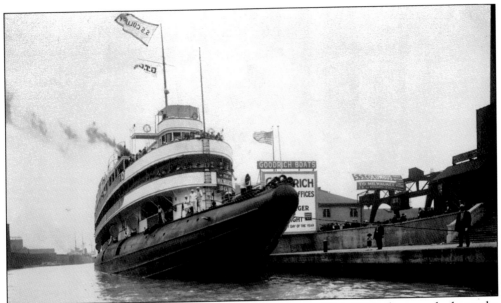

THE CHRISTOPHER COLUMBUS AT THE GOODRICH DOCK. This 1928 photograph shows the *Christopher Columbus* tied up at the Goodrich Dock in Chicago being readied for another trip to Milwaukee. As the signs indicate, the *Christopher Columbus* began her travels between Chicago and Milwaukee each day at 10:00 a.m. at a cost of $1 per passenger on weekdays and $2 on Sundays and holidays. (Courtesy of the Historic Photo Collection/Milwaukee Public Library.)

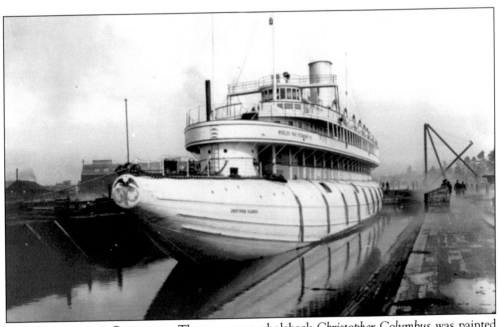

THE CHRISTOPHER COLUMBUS. The passenger whaleback *Christopher Columbus* was painted completely white and had only two decks between May 1892 and the summer of 1894 while she transported passengers to and from the Chicago world's fair. It is estimated that during those two years the *Christopher Columbus* carried more than 2 million passengers. (Courtesy of the Historic Photo Collection/Milwaukee Public Library.)

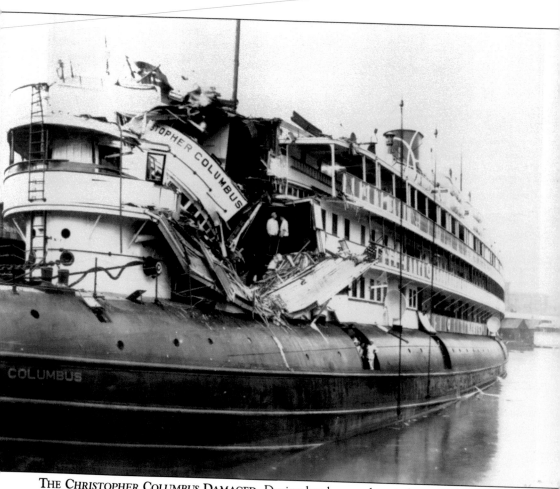

THE CHRISTOPHER COLUMBUS DAMAGED. During her long and storied career, the *Christopher Columbus* had only a single significant accident. On Saturday, June 30, 1917, the *Christopher Columbus*, while being towed by the tugs *Welcome* and *Knight Templar* on the Milwaukee River, was caught by the river's current and swept toward the shore. The tugs were unable to control the movement of the *Christopher Columbus* and the bow of the passenger liner sheered off two legs of the Yahr-Lang Drug Company water tower ashore. The tower fell onto the forward section of the boat crushing the pilothouse and seriously damaging the forward sections of the three decks below. Of the 413 passengers aboard at the time, 16 were killed and more than 20 were injured. The *Christopher Columbus* was repaired and was back in service the next year. (Courtesy of the Historic Photo Collection/Milwaukee Public Library.)

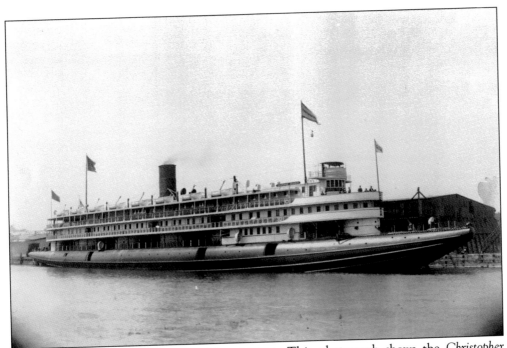

THE CHRISTOPHER COLUMBUS AT MANITOWOC. This photograph shows the *Christopher Columbus* tied up at the Goodrich Dock in Manitowoc, Wisconsin, in 1905. The three large openings used to load and unload passengers can been seen open in the hull of the boat below the white superstructure. (Courtesy of the Historic Photo Collection/Milwaukee Public Library.)

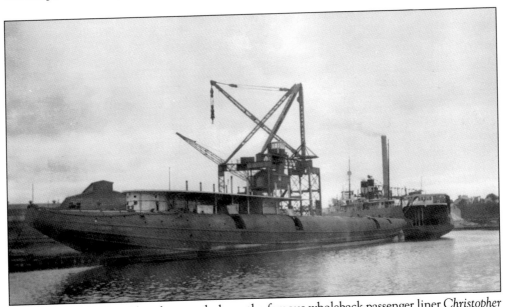

THE END OF AN ERA. This photograph shows the famous whaleback passenger liner *Christopher Columbus* being scrapped at the Manitowoc Shipbuilding Company in Manitowoc, Wisconsin, in September 1936. The final enrollment papers for the *Christopher Columbus* were surrendered at Milwaukee on November 24, 1936. (Courtesy of the Historic Photo Collection/Milwaukee Public Library.)

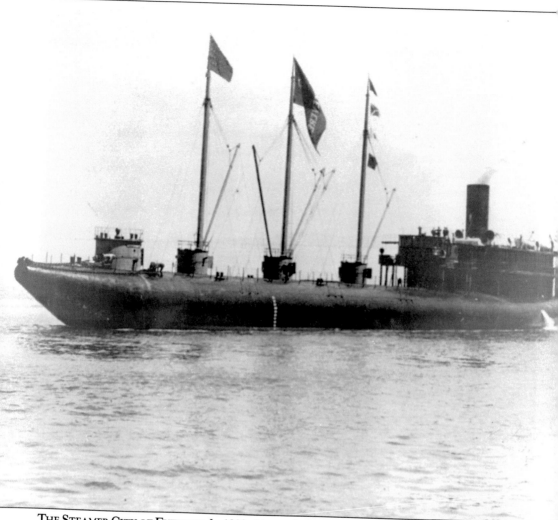

THE STEAMER CITY OF EVERETT. In 1893, Alexander McDougall established a second whaleback shipyard at Everett, Washington. On October 24, 1894, the Pacific Steel Barge Company launched the one and only vessel built by the company: the *City of Everett*. The steamer was 346 feet in length, 42.5 feet of beam, had a draft of 22.9 feet, and could carry 4,200 tons of bulk cargo in her four cargo holds. She was powered by a Frontier Iron Works triple expansion engine capable of 2,300 horsepower. The *City of Everett* never sailed the Great Lakes, remaining on the oceans of the world during her 29-year career. The *City of Everett* became famous as the first American vessel to transit the Suez Canal and the first American ship to circumnavigate the world. In October 1923, the *City of Everett* and her 26-man crew mysteriously disappeared in the Gulf of Mexico as she sailed from Santiago, Cuba, to New Orleans. (Courtesy of the University of Detroit Mercy Special Collections, Fr. Edward J. Dowling, S. J. Marine Historical Collection.)

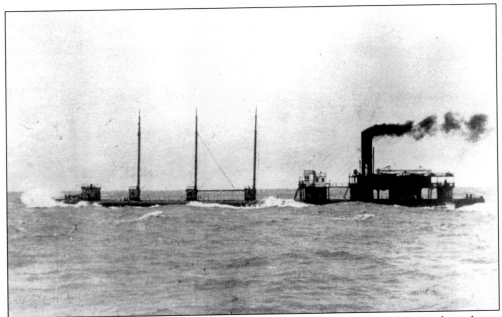

CITY OF EVERETT UNDER STEAM. The *City of Everett*, in this late-1890s photograph, is shown steaming fully loaded into less-than-calm waters off the American coast. Built at an initial cost of $275,000, she sailed for 29 years before sinking in the Gulf of Mexico. (Courtesy of the University of Detroit Mercy Special Collections, Fr. Edward J. Dowling, S. J. Marine Historical Collection.)

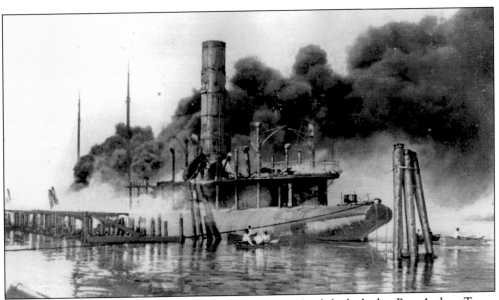

THE CITY OF EVERETT BURNING. On September 8, 1903, while docked at Port Arthur, Texas, the *City of Everett* suffered a catastrophic shipboard fire that burned for 36 hours before fire crews could control the flames. Unbelievably the *City of Everett* was rebuilt after the fire and sailed for another 20 years. (Courtesy of the University of Detroit Mercy Special Collections, Fr. Edward J. Dowling, S. J. Marine Historical Collection.)

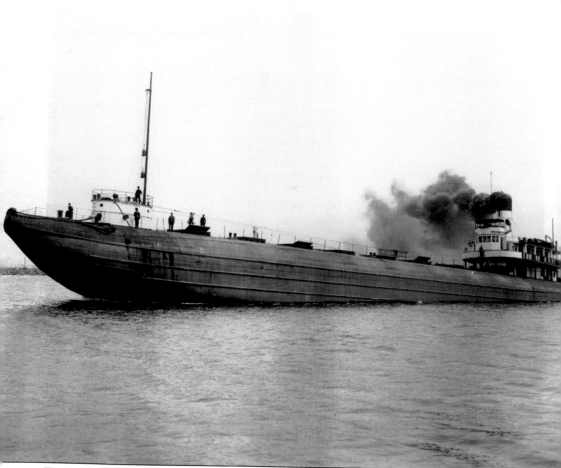

THE JOHN B. TREVOR. The *John B. Trevor*, the 14th whaleback steamer built by Capt. Alexander McDougall, was launched on Wednesday, May 1, 1895, at West Superior, Wisconsin. Although the *John B. Trevor* had four fewer hatches, she was identical to the *Thomas Wilson*, the *Samuel Mather*, and the *James B. Colgate* (all had 12 hatches). She was 308 feet long, 38 feet wide, and had a draft of 24 feet. Initially, she had an S. F. Hodge and Company triple expansion engine capable of 1,100 horsepower. The *John B. Trevor* was outfitted with two Wicks Brothers Scotch boilers with a rating of 160 pounds of pressure per square inch. The *John B. Trevor* had eight hatches on 24-foot centers that led to two cargo compartments holding a total of 3,100 tons of cargo. The boat's number one cargo compartment held 1,750 gross tons of cargo while the number two compartment held 1,350 gross tons. (Courtesy of the Historic Photo Collection/Milwaukee Public Library.)

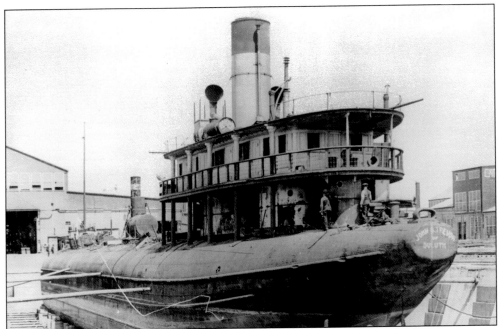

THE JOHN B. TREVOR DRY DOCKED. This 1910 photograph shows the *John B. Trevor* being repaired and converted to the Canadian steamer *Atikokan* after her grounding at Rocky Reef on Isle Royale in Lake Superior in October 1909. (Courtesy of the University of Detroit Mercy Special Collections, Fr. Edward J. Dowling, S. J. Marine Historical Collection.)

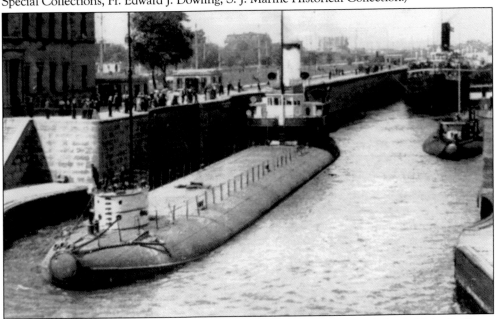

JOHN B. TREVOR AT THE SOO. In this early-1900s photograph, a heavily loaded *John B. Trevor* (left) is shown steaming downbound out of the Soo Locks. An equally heavily loaded whaleback barge (on the right against the lock wall) will be towed behind the *John B. Trevor*. (Courtesy of the University of Detroit Mercy Special Collections, Fr. Edward J. Dowling, S. J. Marine Historical Collection.)

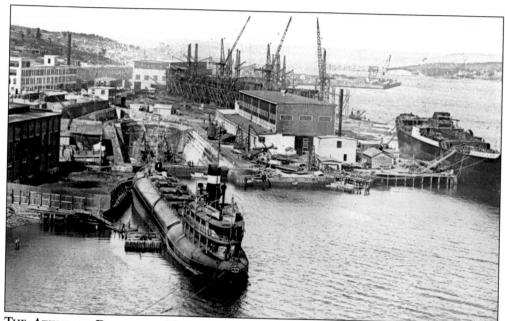

THE ATIKOKAN DOCKED AT HALIFAX. In this photograph, taken between September 1916 and 1935, the steamer *Atikokan* (launched as the *John B. Trevor*) is docked at the Halifax, Nova Scotia, graving docks. The *Atikokan* appears to be undergoing some type of repair or maintenance process as most of the boat is sitting away from the dock and there are ladders on her sides. (Courtesy of the Great Lakes Historical Society.)

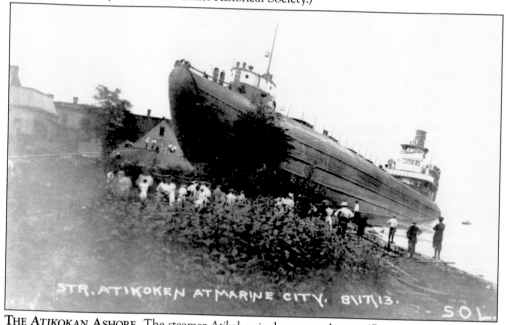

THE ATIKOKAN ASHORE. The steamer *Atikokan* is shown on August 17, 1913, sitting high and dry at Marine City, Michigan, after running up the bank of the St. Clair River. Not only was the *Atikokan* damaged but several buildings ashore suffered damage as a result of the accident. In short order the *Atikokan* was pulled off, repaired, and returned to service. (Courtesy of the Historic Photo Collection/Milwaukee Public Library.)

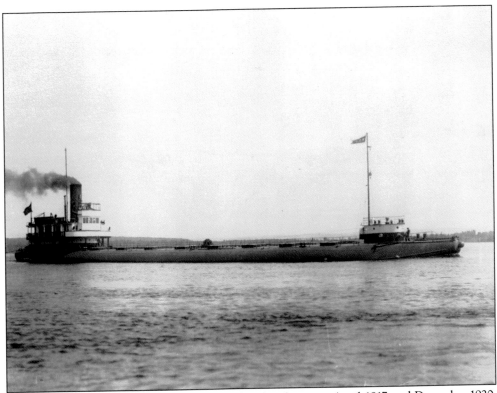

THE STEAMER *ATIKOKAN*. In this photograph, taken between April 1917 and December 1920, the *Atikokan* is running heavily loaded under the flag of the Montreal Transportation Company on one of the connecting waterways of the Great Lakes. The limited freeboard of a loaded whaleback is very evident in this image. (Courtesy of the Historic Photo Collection/Milwaukee Public Library.)

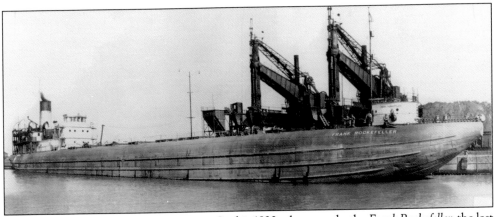

THE *FRANK ROCKEFELLER* UNLOADING. In this 1920s photograph, the *Frank Rockefeller*, the last "pure" whaleback steamer built, is shown at one of the smaller Great Lakes docks unloading iron ore. (Courtesy of the University of Detroit Mercy Special Collections, Fr. Edward J. Dowling, S. J. Marine Historical Collection.)

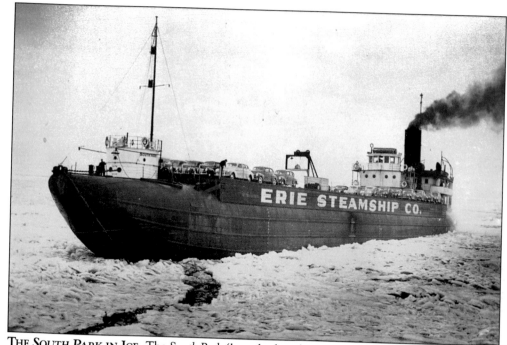

THE SOUTH PARK IN ICE. The *South Park* (launched as the *Frank Rockefeller* on April 25, 1896) transported many new cars on her wooden deck and in her hold in all kinds of weather during the 1920s and 1930s. This winter photograph shows the *South Park* anchored in ice but with her boilers fired. (Courtesy of the University of Detroit Mercy Special Collections, Fr. Edward J. Dowling, S. J. Marine Historical Collection.)

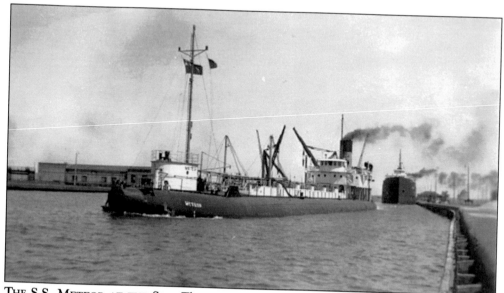

THE S.S. METEOR AT THE SOO. The steamer *Meteor* is shown, under steam and fully loaded with petroleum product, at the Soo Locks in the 1950s. The *Meteor* was used solely as a bulk petroleum tanker for the last quarter century of her sailing career, having been converted to that configuration at the Manitowoc Shipbuilding Company of Manitowoc, Wisconsin, during May–September 1943. (Courtesy of the Michigan Maritime Museum Collection.)

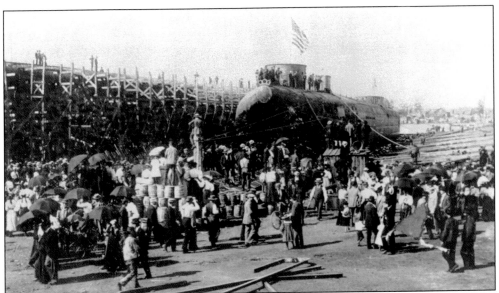

THE LAUNCHING OF THE JOHN ERICSSON. This photograph, taken on Saturday, July 11, 1896, at the ASBC shipyards in West Superior, Wisconsin, shows the hull of the steamer *John Ericsson* ready for launching. The whaleback launchings were festive occasions and were attended by as many as several thousand local folks. (Courtesy of the Historic Photo Collection/Milwaukee Public Library.)

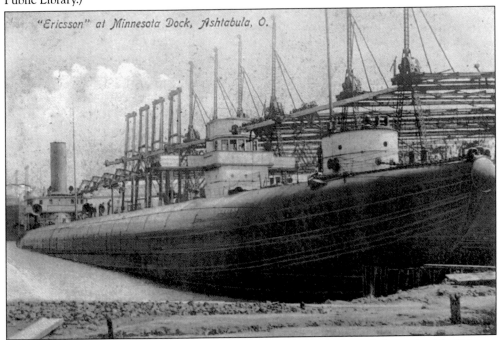

JOHN ERICSSON AT ASHTABULA, OHIO, DOCK. This postcard photograph shows the *John Ericsson* loading coal at the Minnesota Dock in Ashtabula, Ohio. Although she had her pilothouse forward, the *John Ericsson* was the last whaleback steamer built with the normal rounded and tapered whaleback hull. The *John Ericsson* enjoyed a long and productive career on the Great Lakes. (Courtesy of the Michigan Maritime Museum Collection.)

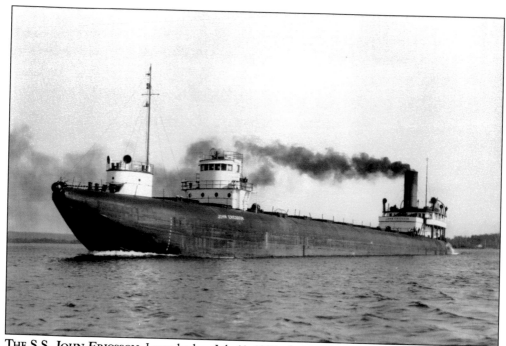

THE S.S. JOHN ERICSSON. Launched on July 11, 1896, the steamer *John Ericsson* was the second to last whaleback steamer ever constructed. The steamer was paired with the whaleback barge *Alexander Holley* for many years and both sailed the Great Lakes for 70 plus years. (Courtesy of the Historic Photo Collection/Milwaukee Public Library.)

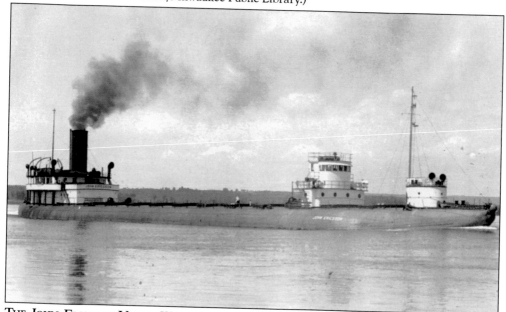

THE JOHN ERICSSON UNDER WAY. The steamer *John Ericsson* is shown steaming on one of the connecting waterways of the Great Lakes with a full hold of bulk cargo load, most likely iron ore. The forward pilothouse configuration and the standard whaleback hull of the *John Ericsson* are very visible and make the boat very easy to identify. (Courtesy of the Historic Photo Collection/Milwaukee Public Library.)

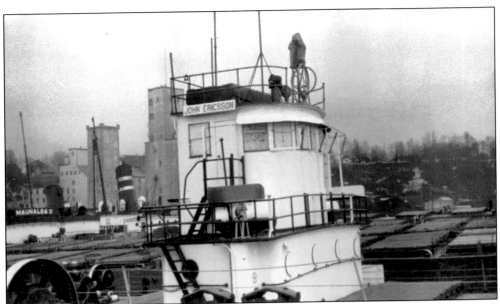

THE JOHN ERICSSON AND THE MAUNALOA II. In an odd bit of fate, the *John Ericsson* (foreground) and the steamer *Maunaloa II* (background) share a winter lay up at Goodrich, Ontario, on March 15, 1958. On Lake Superior 56 years earlier the *Maunaloa II* (then named simply *Maunaloa*) rammed whaleback *Barge 129* and sent her to the bottom 30 miles northwest of Vermilion Point, Michigan. (Courtesy of Great Lakes Historical Society.)

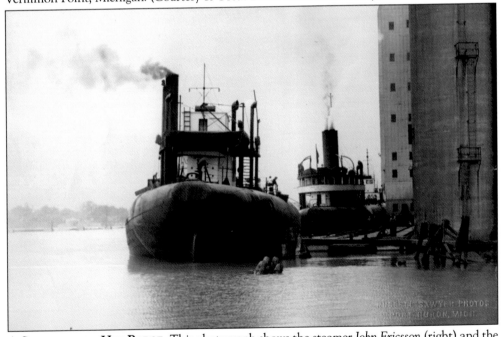

A STEAMER AND HER BARGE. This photograph shows the steamer *John Ericsson* (right) and the barge *Alexander Holley* (left) tied up at the grain elevators at Midland, Ontario, on July 9, 1947. The *John Ericsson* and the *Alexander Holley* were paired for most of their careers on the Great Lakes. After almost 70 years of sailing, both were scrapped in the mid-1960s. (Courtesy of the Great Lakes Historical Society.)

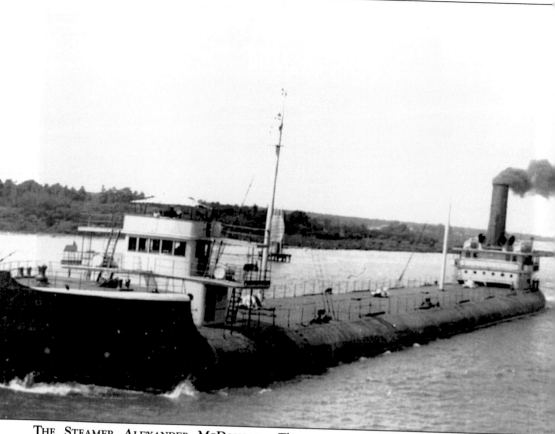

THE STEAMER ALEXANDER MCDOUGALL. The appropriately named steamer *Alexander McDougall* was the last whaleback boat ever constructed by Capt. Alexander McDougall and the ASBC. She was launched from West Superior on Monday, July 25, 1898. The *Alexander McDougall* was well and away the largest whaleback ever constructed with a length of 413 feet, a beam of 50 feet, and a draft of 22 feet. She had 13 hatches on 24-foot centers leading to four cargo compartments that could hold a total of 6,800 tons of bulk cargo. The *Alexander McDougall* was the first and only whaleback to be outfitted with a quadruple expansion engine. She was also the only whaleback built with a conventional bow. The bow was an attempt to increase the strength of the hull so that the boat's beam could be increased. Neither the bow nor the additional internal supports added to the hull solved the problem and the end of the whalebacks as a viable transportation option loomed large. (Courtesy of the Michigan Maritime Museum Collection.)

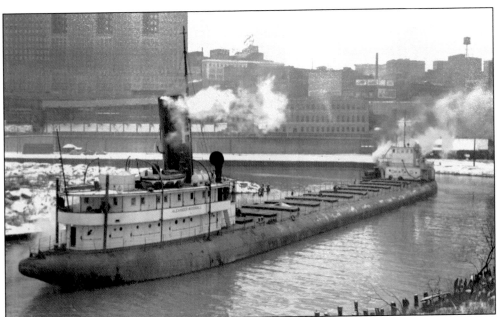

A Tight Turn. This December 5, 1940, photograph shows the steamer *Alexander McDougall* beginning the turn at "Collision Bend" on the Cuyahoga River in downtown Cleveland. The very tight turns on many of the rivers and connecting waterways of the Great Lakes made the job of maneuvering the large boats along the winding water paths extremely challenging. (Courtesy of the Great Lakes Historical Society.)

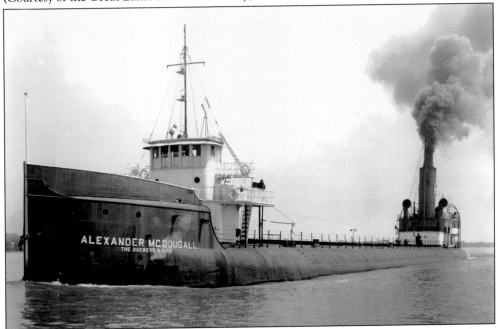

The S.S. Alexander McDougall. This photograph, taken between July 17, 1936, and July 29, 1943, clearly shows the conventional bow and the forward pilothouse on the steamer *Alexander McDougall* along with the curved hull of the standard whaleback—the only whaleback so constructed. (Courtesy of the Historic Photo Collection/Milwaukee Public Library.)

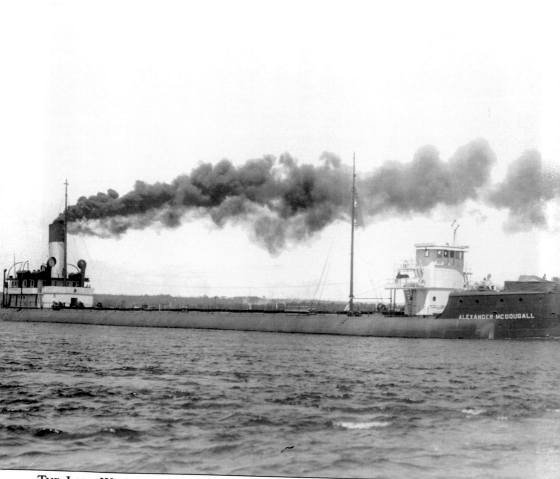

THE LAST WHALEBACK. The last whaleback ever built, the *Alexander McDougall* was the last gasp of a dying breed. It became obvious that the whalebacks could not be made large enough—due to their own internal structural deficits—to compete with the larger and larger steel steamers being built all around the Great Lakes in the 1890s. The *Alexander McDougall* sailed the Great Lakes for well on 45 years before she was traded in for a newer steamer during World War II. The *Alexander McDougall* was laid up, joining many other older Great Lakes boats sitting idle off Erie, Pennsylvania, until the end of the war. In October 1946, the *Alexander McDougall* was towed to Hamilton, Ontario, where she was scrapped. Her final documents were surrendered at Wilmington, Delaware, in late January 1946. (Courtesy of the Historic Photo Collection/Milwaukee Public Library.)

Four

THE S.S. METEOR,
THE LAST WHALEBACK

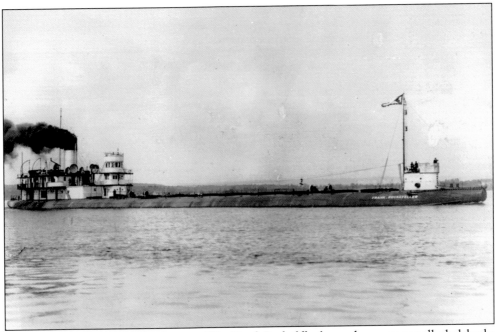

THE LONGEST SERVING WHALEBACK. The *Frank Rockefeller* began her career as all whalebacks did, hauling bulk cargos across the Great Lakes. There was no hint in her early days that she would become the longest serving whaleback in history. The *Frank Rockefeller* was originally constructed with 10 hatches on 24-foot centers opening to three cargo compartments in her hull with a combined capacity of 5,200 tons. She has passed the 100-year mark and is still going strong. (Courtesy of the University of Detroit Mercy Special Collections, Fr. Edward J. Dowling, S. J. Marine Historical Collection.)

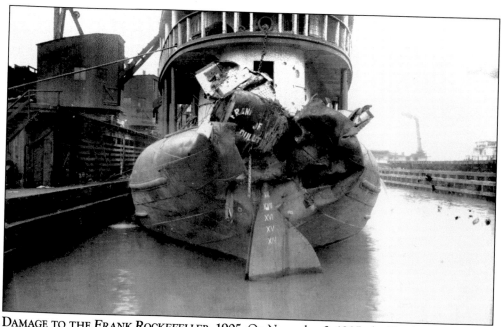

DAMAGE TO THE FRANK ROCKEFELLER, 1905. On November 3, 1905, the *Frank Rockefeller* ran aground at Rainbow Cove on Isle Royale while towing the barge *Maida*. The *Maida* ran into the stern of the *Frank Rockefeller* causing significant damage to the steamer. The *Frank Rockefeller* was towed to Two Harbors, Minnesota, for repairs and was returned to service in fairly short order. (Courtesy of the Great Lakes Historical Society.)

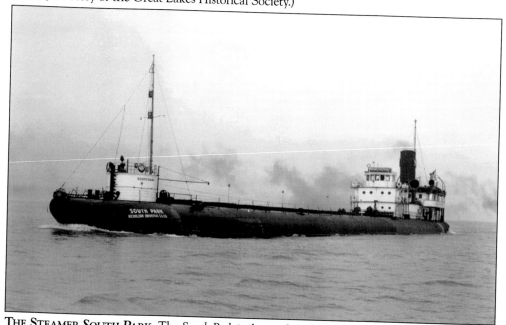

THE STEAMER SOUTH PARK. The *South Park* is shown downbound on Lake St. Clair (one of the waterways connecting Lake Erie and Lake Huron) loaded with bulk cargo on July 11, 1942. The *South Park* displays her bulk carrier configuration after her conversion from sailing the Great Lakes as an automobile carrier for many years. (Courtesy of the Historic Photo Collection/Milwaukee Public Library.)

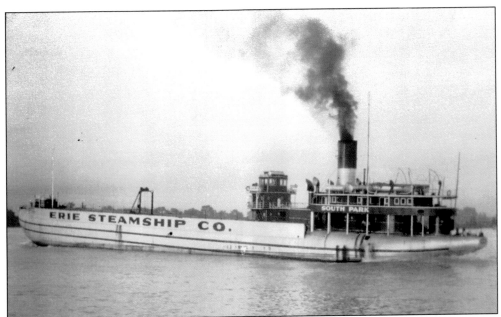

THE SOUTH PARK AS AN AUTOMOBILE CARRIER. The *South Park* was converted from a bulk cargo carrier to an automobile carrier in 1936. In this configuration, the *South Park* was equipped with a flat removable wooden deck fitted over her curved metal hull and an elevator into her hold so that she could carry vehicles both on and below her main deck. (Courtesy of the Historic Photo Collection/Milwaukee Public Library.)

THE SOUTH PARK AT SUPERIOR. In this early-1940s photograph, the *South Park* is shown loading a hold full of wheat from the Farmers Union Elevator at Superior, Wisconsin. The *South Park* had the distinction of being the first boat to load grain from the elevator. (Courtesy of the University of Detroit Mercy Special Collections, Fr. Edward J. Dowling, S. J. Marine Historical Collection.)

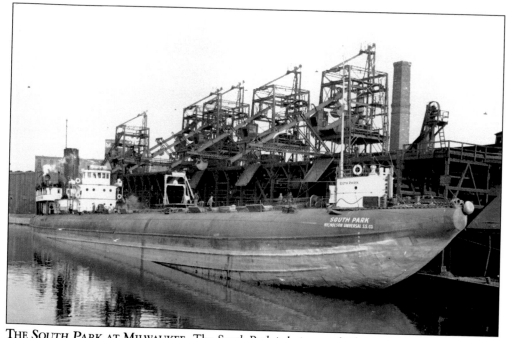

THE SOUTH PARK AT MILWAUKEE. The *South Park* is being readied to receive a load of coal at a Milwaukee dock on November 4, 1941. Her deck crew is opening her cargo hatches and the chutes used to slide the coal into her three cargo holds are at the ready. (Courtesy of the Historic Photo Collection/Milwaukee Public Library.)

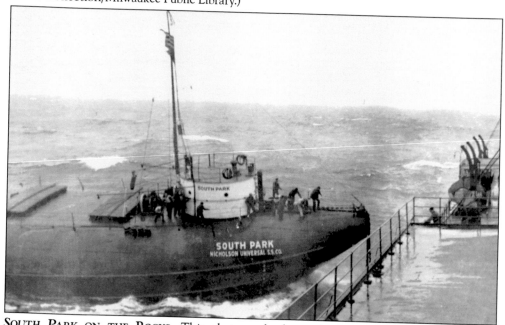

SOUTH PARK ON THE ROCKS. This photograph shows the rescue of the *South Park* on October 27, 1942, after she went aground at Point Betsie, Michigan, during a storm. The crewmen around the turret are working to save their boat after rocks damaged a number of the *South Park's* hull plates. Thankfully none of the crew was injured during the incident. (Courtesy of the Historic Photo Collection/Milwaukee Public Library.)

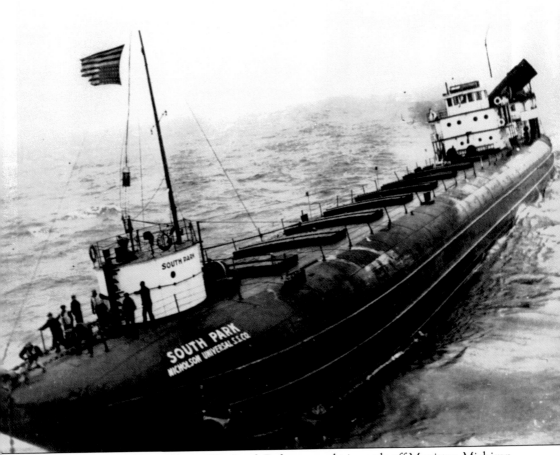

THE WRECK OF THE SOUTH PARK. The *South Park* was caught in a gale off Manistee, Michigan, on October 27, 1942, and subsequently blown hard aground near Point Betsie, Michigan, after her rudder broke. The grounding pierced a number of her hull plates and put the boat and her crew at significant risk. This photograph, taken from the deck of one of the boats that came to her assistance, shows the *South Park* in very serious difficulty as she is on the rocks, listing to starboard and her funnel (behind the pilothouse) has been blown over. The American flag on her forward mast is being flown upside down—a well-known signal of distress on the Great Lakes. Eight members of the *South Park*'s crew are shown at the bow working the anchors in an effort to save their boat. Fortunately the crew and the boat were saved, all to sail another day. (Courtesy of the Historic Photo Collection/Milwaukee Public Library.)

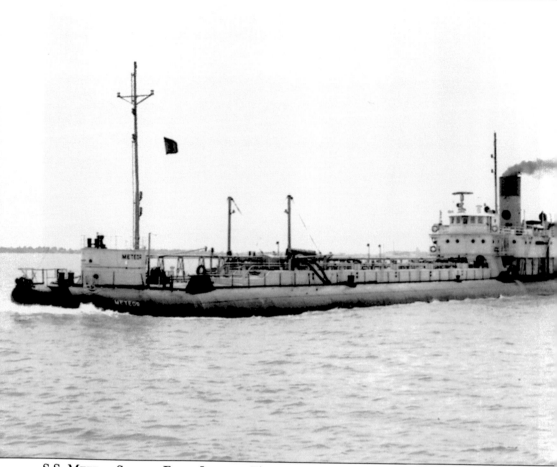

S.S. Meteor Sailing Fully Loaded. The steamer *Meteor* (launched as the *Frank Rockefeller* on April 25, 1896) is seen sailing the Great Lakes sometime between 1943 and 1969 under the Cleveland Tankers flag. The *Meteor* is shown fully loaded with the equivalent of 40,000 barrels of bulk liquid in her hull on calm Great Lakes waters. After a minor accident near Marquette, Michigan, in November 1969, Cleveland Tankers laid the *Meteor* up at Manitowoc, Wisconsin, while they determined whether she would be repaired or scrapped. When the decision to dispose of the steamer was made, she was offered to the City of Superior as a gift. The offer was accepted and the *Meteor* was towed to Superior by the tug *John Roen V*, arriving on September 11, 1972. The *Meteor* now serves in her second career as a wonderful maritime museum, offering a unique window to the past. (Author's collection.)

THE *METEOR* FROM ABOVE. In this wonderful photograph, taken from the Blue Water Bridge above the St. Clair River at Port Huron, Michigan, and Sarnia, Ontario, in the early 1960s, the maze of piping and petroleum transfer equipment on the deck of the *Meteor* is clearly evident. (Courtesy of the Great Lakes Historical Society.)

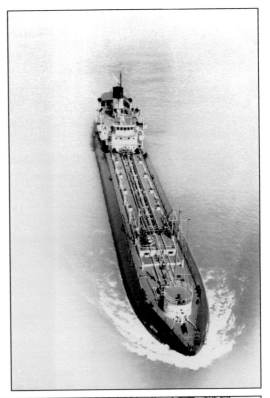

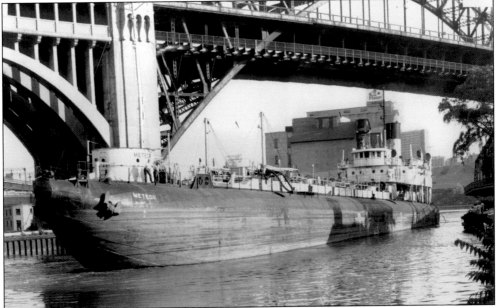

THE *METEOR* ON THE CUYAHOGA RIVER. An empty *Meteor* runs slowly north along the Cuyahoga River in Cleveland under the Detroit-Superior Viaduct (now the Veterans Memorial Bridge) in the early 1960s. The difficult job of maneuvering a large boat in the very narrow river is obvious. (Courtesy of the University of Detroit Mercy Special Collections, Fr. Edward J. Dowling, S. J. Marine Historical Collection.)

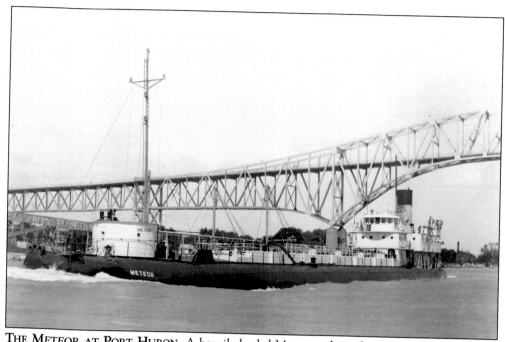

THE METEOR AT PORT HURON. A heavily loaded *Meteor* sails under the famous Blue Water Bridge that spans the St. Clair River at Port Huron, Michigan, in the early 1960s. (Courtesy of the University of Detroit Mercy Special Collections, Fr. Edward J. Dowling, S. J. Marine Historical Collection.)

A NEW BOW PLATE. The *Meteor* is shown having a new steel plate riveted to her bow on February 4, 1959, during her winter lay up. Repairs such as this were common for many Great Lakes boats during their lay up period so that the repairs did not idle the boats during the money-making season. (Courtesy of the Great Lakes Historical Society.)

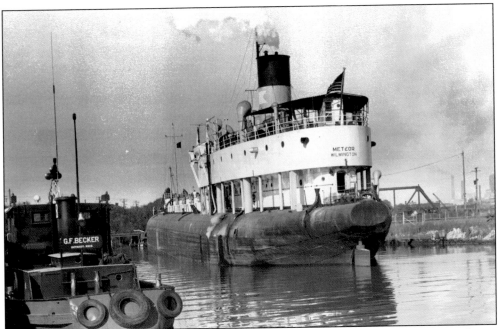

The Meteor at River Rouge. This mid-1960s photograph shows the *Meteor* completing the discharge of a load of gasoline at the Cities Services dock at River Rouge, one of southeast Michigan's largest industrial complexes, on the Detroit River. (Courtesy of the University of Detroit Mercy Special Collections, Fr. Edward J. Dowling, S. J. Marine Historical Collection.)

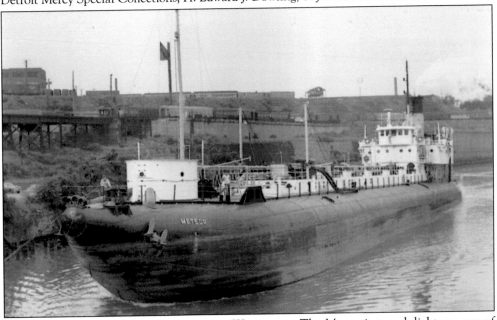

S.S. Meteor Towed on a Connecting Waterway. The *Meteor* is towed, light, on one of the inland waterways of the Great Lakes. The photograph gives a good indication as to how high the whalebacks rode out of the water without cargo in their holds. The light-colored waterline along the hull shows just how deep the whalebacks settled into the water with a full load. (Author's collection.)

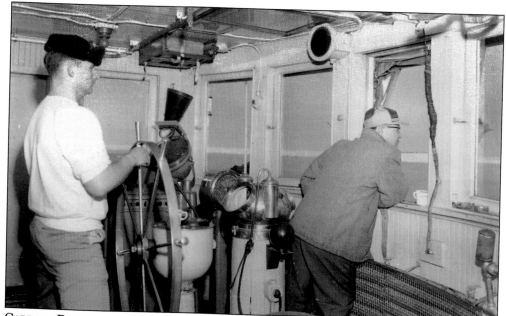

CAPTAIN BOLLIN IN THE PILOTHOUSE. In the early 1960s, Capt. Fritz Bollin of Toledo, Ohio, the master of the *Meteor* for 23 years (1945 to 1968), is guiding the boat from the traditional post of all Great Lakes captains: the center window of the pilothouse. Also traditional in Great Lakes pilothouses is the cup of coffee at Bollin's right elbow. (Courtesy of the Superior Public Museums.)

THE METEOR'S CHARTROOM. During the early 1960s, the *Meteor*'s first mate Robert Kinsey is shown in the steamer's chartroom, situated directly behind the pilothouse, working on the chart cabinet to plot the boat's course and to log the vast amount of information required by the owners and state and federal regulations. The *Meteor*'s gyrocompass was also situated in the chartroom. (Courtesy of the Superior Public Museums.)

MEAL TIME ON THE *METEOR*.
Several of the *Meteor*'s mid-1960s
crewmen enjoy another great meal in
the crew's mess, with homey touches
like the table cloth, substantial
portions, and good conversation. The
meals aboard the *Meteor* were one of
the highlights of any day for the crew.
The door behind the crewmen leads
to the *Meteor*'s galley. (Courtesy of
the Superior Public Museums.)

KEEPING THE CREW HAPPY. This
early-1960s photograph shows the
Meteor's steward Martin Bielek
cooking up another delicious meal in
the galley for the boat's officers and
crew. The moral of a boat's crew was
directly related to the quality of the
meals they were served, and that made
the stewards on Great Lakes boats very
important people. (Courtesy of the
Superior Public Museums.)

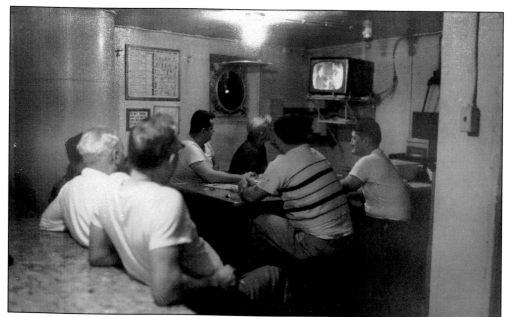

THE METEOR'S CREW'S MESS. During the early 1960s, several *Meteor* crewmembers of the off-duty shifts gather in the crew's mess to watch the small black-and-white television and socialize. The crew's mess is the gathering place and social hub of any Great Lakes boat with conversation, cards, meals, story telling, and hot coffee all in never-ending supply. (Courtesy of the Superior Public Museums.)

THREE METEOR CREWMEMBERS. This photograph shows three of the *Meteor*'s mid-1960s crewmembers relaxing off duty on the boat deck. The work aboard the *Meteor* was difficult, as it was on most Great Lakes steamers, and made the crews a very tight group. Many of the friendships forged on the boats lasted a lifetime. (Courtesy of the Superior Public Museums.)

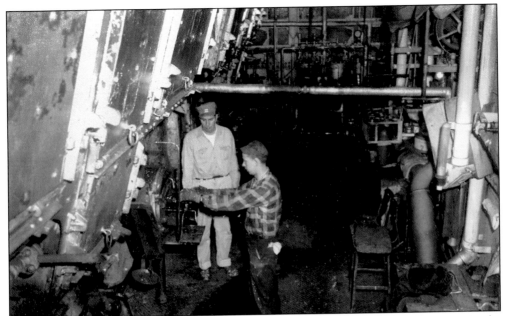

THE METEOR'S BOILER ROOM. Two crewmen are shown in the *Meteor*'s boiler room in the mid-1960s. During the early days of the *Frank Rockefeller* and the *South Park*, this area was where the coal passers shoveled coal into the boilers—pretty much the worst (and hottest) job on the boats. During the mid-1940s, the *Meteor* was altered to burn oil instead of coal. (Courtesy of the Superior Public Museums.)

TWO CREWMEMBERS RELAX. Two of the *Meteor*'s mid-1960s crew take the opportunity to break the shipboard routine and catch a breath of fresh Great Lakes air on the boat deck. The white structure to the left is the *Meteor*'s pilot/chart house. (Courtesy of the Superior Public Museums.)

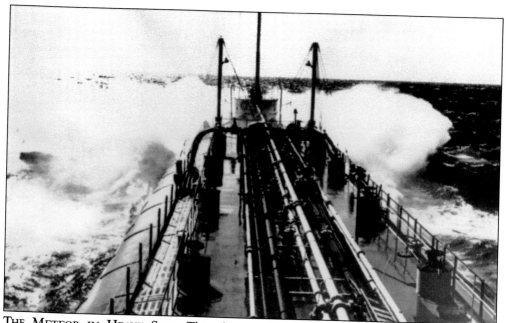

THE METEOR IN HEAVY SEAS. This photograph, taken just outside the pilothouse, was snapped by a crewman aboard the *Meteor* in the late 1960s as the boat plowed through heavy seas on the Great Lakes. The jumble of piping and equipment required for the *Meteor's* job as a bulk fuel tanker can be seen on the deck of the boat. (Courtesy of the Historic Photo Collection/Milwaukee Public Library.)

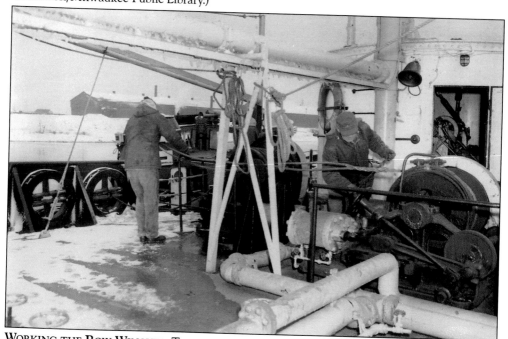

WORKING THE BOW WINCHES. Two crewmen are shown braving the cold and snow to work the *Meteor's* bow winches to tie the boat up to a Great Lakes dock. In the background, the door to the forward turret is open and a portion of the anchor winch inside the structure can be seen. (Courtesy of the Superior Public Museums.)

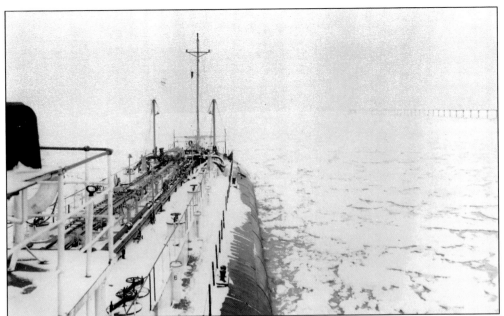

THE METEOR BREAKING ICE. Due to the unique shape of their bows, the whaleback steamers served over many years as icebreakers on the Great Lakes. Their bows allowed the boats to easily ride up on the ice and then crush the ice with the weight of their hulls. This photograph shows the *Meteor* moving through broken, but still dangerous, ice in the mid-1960s. (Courtesy of the Superior Public Museums.)

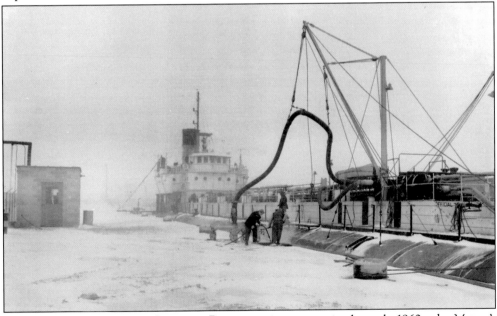

THE METEOR LOADING AT CHICAGO. During a winter storm in the early 1960s, the *Meteor*'s crew is loading petroleum product at the Phillips Loading Dock in Chicago. The flexible piping being held by the booms and rigging sends the liquid product from the storage tanks at the dock through the piping on the *Meteor*'s deck to its designated cargo tank within the *Meteor*'s hull. (Courtesy of the Superior Public Museums.)

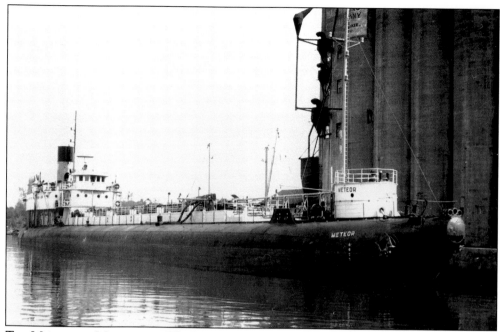

THE METEOR AT MILWAUKEE. The *Meteor* is shown gliding past a number of grain elevators at Milwaukee en route to one of the petroleum loading facilities on the Milwaukee River to load any number of different petroleum products into the several separate tanks within her hull. (Courtesy of the Superior Public Museums.)

CLOSE QUARTERS. This early-1960s photograph shows the confined waterways, canals, and rivers in which the *Meteor* (and all Great Lakes steamers) had to navigate to pick up and deliver their cargos. The clearance between the *Meteor*'s hull and the piling under the draw bridge is approximately 10 feet. Even with the assistance of the tug at the *Meteor*'s bow, the squeeze is very tight. (Courtesy of the Superior Public Museums.)

S.S. Meteor

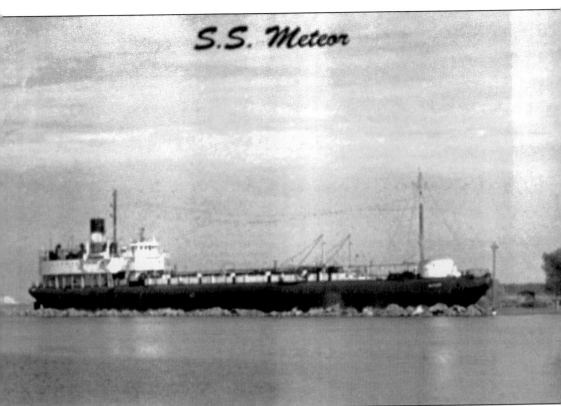

THE METEOR AT SUPERIOR, WISCONSIN. The *Meteor* is shown at her final berth on the north end of Barker's Island in Superior, Wisconsin, approximately a mile and a half south of where she was built more than 100 years ago. The *Meteor*, operated by the Superior Public Museum, is now a remarkable museum ship open for guided tours during the summer and fall months. The initial exploration of the *Meteor* begins as one walks through what was the *Meteor's* hold to view numerous exhibits of whaleback and Great Lakes history, including the steering wheels of the wrecked whalebacks *Sagamore* and *Thomas Wilson*, the bell of the *Alexander McDougall*, and many photographs and beautiful boat models. The tour through the boat is led by one of the *Meteor's* very informative and congenial guides and takes one through the pilothouse, chart room, captain's cabin/office, crew's quarters, mess, galley, and engineering spaces. (Courtesy of the Michigan Maritime Museum Collection.)

Discover Thousands of Local History Books Featuring Millions of Vintage Images

Arcadia Publishing, the leading local history publisher in the United States, is committed to making history accessible and meaningful through publishing books that celebrate and preserve the heritage of America's people and places.

Find more books like this at
www.arcadiapublishing.com

Search for your hometown history, your old stomping grounds, and even your favorite sports team.

Consistent with our mission to preserve history on a local level, this book was printed in South Carolina on American-made paper and manufactured entirely in the United States. Products carrying the accredited Forest Stewardship Council (FSC) label are printed on 100 percent FSC-certified paper.

MADE IN THE USA